MW00364413

POSTCARD HISTORY SERIES

The North Penn Community

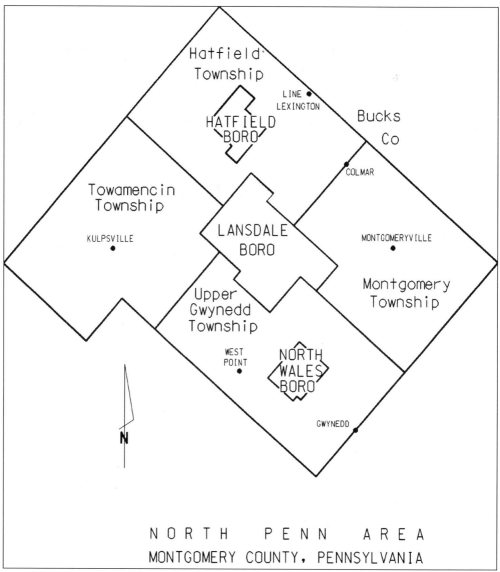

THE NORTH PENN REGION. Located entirely in Montgomery County near the Bucks County line, the North Penn area is approximately 25 miles north of Philadelphia. It is made up of the townships of Hatfield, Montgomery, Towamencin, and Upper Gwynedd; the boroughs of Hatfield, Lansdale, and North Wales; and several small villages. This volume is the first study of this historic region.

POSTCARD HISTORY SERIES

The North Penn Community

Andrew Mark Herman

ARCADIA

Copyright © 2002, by Andrew Mark Herman.
ISBN 0-7385-1116-1

First printed in 2002.
Reprinted in 2003.

Published by Arcadia Publishing,
an imprint of Tempus Publishing, Inc.
2A Cumberland Street
Charleston, SC 29401

Printed in Great Britain.

Library of Congress Catalog Card Number: 2002109308

For all general information contact Arcadia Publishing at:
Telephone 843-853-2070
Fax 843-853-0044
E-Mail sales@arcadiapublishing.com

For customer service and orders:
Toll-Free 1-888-313-2665

Visit us on the internet at http://www.arcadiapublishing.com

This book is dedicated to Lauren, Ali, and Maddie.

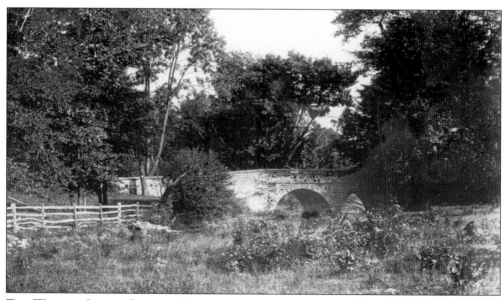

THE WALNUT STREET BRIDGE, NORTH WALES, 1910. Country scenery dominated the North Penn area in the early 20th century, as revealed in many postcard views of that time. North Wales photographer and postcard publisher W.W. Miller captured this scene of the old Walnut Street Bridge at the Wissahickon Creek.

CONTENTS

ACKNOWLEDGMENTS

It is with extreme gratitude that I offer my heartfelt appreciation to the following individuals for their kindness and support: Claudia Herman, for many hours of aid in preparation; Richard Stricker, Annette Krimm, Francis Krimm, Jane Walton, and Richard Shearer of the Lansdale Historical Society; Alberta Fuss of North Wales; Phyllis Byrne of the North Wales Historic Commission; and Henry Scholz of Ambler, Pennsylvania.

BIBLIOGRAPHY

Blase, Francis. *Heebener & Sons, Pioneers of Farm Machinery in America.* 1984.
Commemorative Book—Lansdale, Pennsylvania Centennial 1872–1972. 1972.
Jennings, Lucinda. *Tracing Lansdale's Past.* 1972.
North Wales Centennial Celebration Committee. *Centennial of the Borough of North Wales, 1869–1969.* 1969.
Ruth, Phil Johnson. *Fairland Gwynedd.* Souderton, Pennsylvania: Indian Valley Printing Company, 1991.
———. *Hatfield Township, Through the Eyes of Time, A 250th Anniversary Album.* Souderton, Pennsylvania: Ploughman Publishing, 1992.
Specht, J. Henry. *A History of Towamencin Township.* 1954.
Williams, James A. *An Erudite Little Township, A History of Montgomery Township to 1900.* 1979.

INTRODUCTION

A wilderness area inhabited by Native Americans became a land grant to William Penn by King Charles II in 1681. Within a year, Pennsylvania had been founded and European settlements began to develop in three original counties: Philadelphia, Bucks, and Chester. The North Penn area was originally part of Philadelphia County. Montgomery County was created in 1784.

The North Penn region has been characterized as "gently rolling land," with small hills and valleys, approximately 400 feet above sea level. The land has an abundance of creeks and springs and has been described as "well watered." Principle streams are the Wissahickon and Neshaminy Creeks. Both have their source, a series of underground springs, in the North Penn region.

The first settlers to take advantage of William Penn's land grants, as well as his freedom for religious worship, were the Welsh Quakers and Welsh Baptists. They were followed by German Mennonites, Schwenkfelders, and Lutherans.

Gwynedd Township appears to be the first area to be named. Dating from 1698, the township was later divided into Upper and Lower Gwynedd. Two Welsh Quakers, William Jones and Thomas Evans, bought land in 1698. Gwynedd is Welsh for "fair land." By 1700, a log Quaker Friends meetinghouse had been built. In 1700–1701, William Penn visited the Gwynedd Quakers, and the William Penn Inn is named in his honor, as well as his visit to the area. In 1714, Montgomery Township was incorporated. This area was also settled by Welsh Quakers; however, in 1719, the Welsh Baptists erected their first church in the township in the present-day town of Colmar. Towamencin Township was founded in 1728. Towamencin is a Native American term meaning poplar tree. As early as 1702, German Mennonites inhabited Towamencin. In 1725, they erected their first meetinghouse. Hatfield Township was created in 1742 and, in 1898, the lower and upper Hatfield villages became Hatfield Borough. North Wales was incorporated in 1869, followed by Lansdale Borough in 1872.

Lansdale and North Wales Boroughs owe their existence to the railroad, specifically the North Pennsylvania Railroad, established in Philadelphia in 1852. Within several years, the railroad line had cut a path through the middle of these two towns. The North Penn area takes its name from the North Penn or North Pennsylvania Railroad.

Other factors that helped influence early development of the area were the roads. Welsh Road dates from 1702 to 1712, connecting Gwynedd Township to the Pennypack Creek. Bethlehem Pike dates from 1717, followed by Sumneytown Pike in 1735, and Cowpath Road and Swede Road/State Road (Route 202).

As rail lines and roads became more frequented, the North Penn area began to grow. Lansdale and North Wales grew rapidly, and many industries located along the railroad found easy access

for delivering their products to markets such as Philadelphia. Philadelphia had the greatest impact on the region. By the mid-1900s, the Pennsylvania Turnpike and Route 309 expressway were built, allowing easy access to the city and establishing the North Penn area as a desirable suburb. However, the rapid suburbanization of the area has taken its toll on the landscape. Traffic congestion is now a major problem and many farms and open spaces are gone. For the most part, many old homes and villages remain amidst the sprawl of the 21st century.

Two local postcard publishers and photographers are responsible for many of the images presented in this book. John Bartholomew (1861–1943) operated a photography studio in Lansdale for 52 years. His first studio was on Walnut Street between Main and Second Streets. Next, he moved to a larger place on Courtland Street near Susquehanna Avenue. Later, with his son Nevin, he moved to West Main Street at Richardson Avenue. He profusely documented Lansdale in photographic postcards. He also published views of Central Montgomery and Bucks Counties.

W.W. Miller (1885–1960) was a lifelong resident of North Wales. On the reverse or address side of his postcards, he has listed the Rorer Building in North Wales as his studio. Miller was a graduate of the Philadelphia School of Industrial Art and, like Bartholomew, published extensive views of his home town. He also made postcard views of a good portion of Montgomery and Bucks Counties.

Miller published views of Lansdale, and Bartholomew produced many views of North Wales, which perhaps made their business relationship a friendly rivalry or a fierce competition. They both left behind a wonderful legacy of postcard views depicting our area during the late-19th and early-20th centuries. Without these important men, along with others, such as William Sliker of Philadelphia, some scenes might have been lost forever.

Several local historical societies and groups have not only been helpful with regards to this book, but offer our region a great source of information concerning the North Penn area's past. The Lansdale Historical Society operates a museum and the North Penn Historical Library in Lansdale. The North Wales Historic Commission worked very hard to establish the North Wales Historic Preservation District in 1999, which helps monitor and protect about 250 buildings in the borough. Other groups include the Montgomery Township Historical Society and the Hatfield Historical Society.

With regards to this book, effort has been made to include prominent places as well as the lesser known aspects of life in the North Penn region. It would be impossible to cover everything in our area, and this book is limited to the postcards owned by the author. Therefore this book is not a history of North Penn, but rather an illustrated look at this unique and historic region.

This book celebrates life in this richly historic area, and encourages learning and respect of its natural resources and historic properties.

—Andrew Mark Herman
May 21, 2002

One
THE LANSDALE BUSINESS DISTRICT

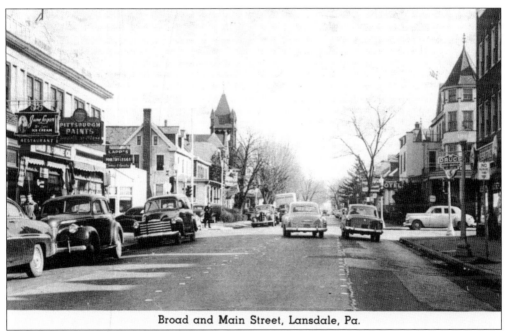

Broad and Main Street, Lansdale, Pa.

BROAD AND MAIN STREETS, LANSDALE, 1952. This is Main Street looking east toward the intersection of Broad Street. This intersection has always been the center of downtown Lansdale and contains a variety of stores and businesses. Across Broad Street on the right is the Eitherton Hotel, and in the near right is a portion of the Tremont Hotel. Neither hotel still stands. In the distance is the steeple of the old Trinity Lutheran Church, which also no longer stands. (Art-Glo postcard.)

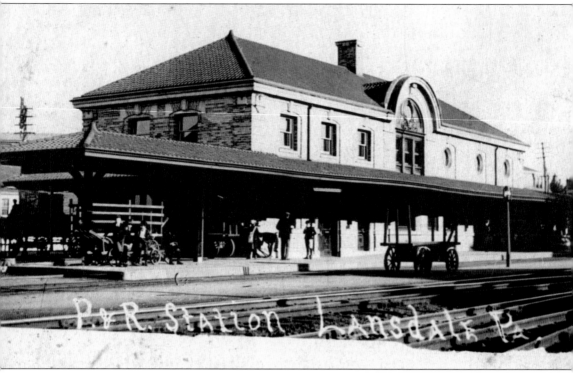

THE P & R STATION, LANSDALE, 1905. The birth and existence of Lansdale revolves around its train station. The North Pennsylvania Railroad began construction of a line from Philadelphia to Bethlehem. Midway between these points is where the station and town of Lansdale were created. The chief surveyor for the railroad was Philip Lansdale Fox, who settled in the area while working on the line. The name of Lansdale Borough was taken from his middle name; North Penn was named for the North Pennsylvania Railroad. The original wooden station was built in the 1860s. This view shows the west side of the station that was built in 1902. (Bartholomew postcard.)

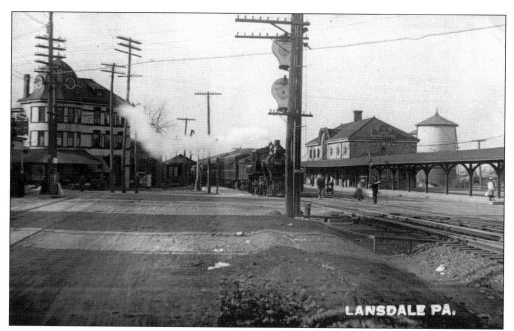

LANSDALE, 1910. An old steam railroad train is about to cross Main Street in front of the station. To the left is the J.F. Zane Bakery, also known as the Beinhacker Building, a large imposing structure in Lansdale's early business district. (Bartholomew postcard.)

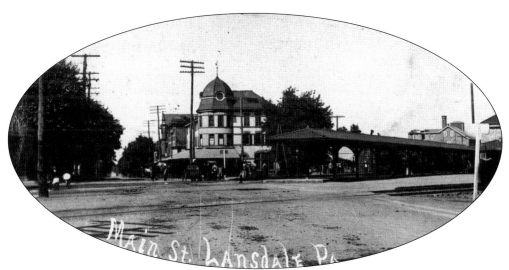

MAIN STREET, LANSDALE. This 1905 oval postcard view shows West Main Street looking west at the railroad crossing. Main Street seems rather quiet and empty, with only a few pedestrians and carriages in view. The large building in the center was occupied by the Zane Bakery. That building was torn down *c.* 1970. This street view offers a detailed glimpse of Lansdale's business district at the beginning of the 20th century. (Bartholomew postcard.)

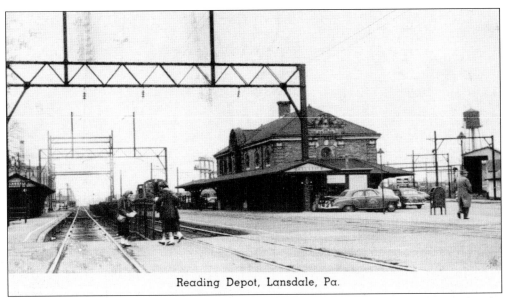

Reading Depot, Lansdale, Pa.

THE READING DEPOT, LANSDALE. The North Pennsylvania line was bought out by the Reading Railroad in the late 1800s. This 1952 view shows the Lansdale Station looking north from where the tracks cross Main Street. Today, the station is still in use and has been restored by the Southeastern Pennsylvania Transportation Authority (SEPTA). (Art-Glo postcard.)

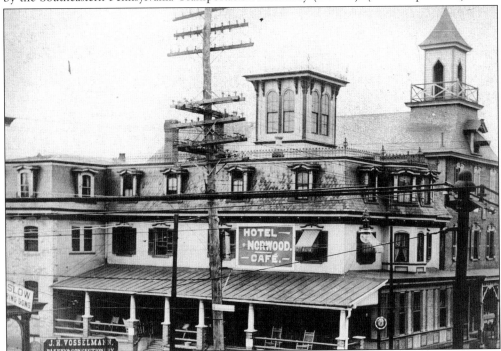

THE HOTEL NORWOOD, LANSDALE. The Hotel Norwood, also known as the Norwood Hotel, was one of Lansdale's first hotels. This building was most likely built before 1860 and stood at Main Street and Susquehanna Avenue, a short distance from the busy railroad station. The building to the right, known as Freeds Hall, was built by A.G. Freed, and contained stores and offices. Neither building still stands. (Bartholomew postcard.)

12

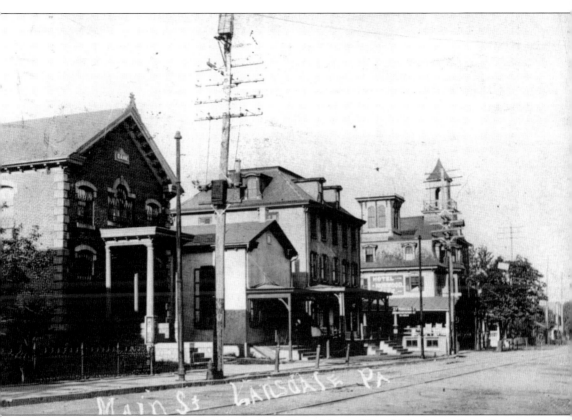

MAIN STREET, LANSDALE, 1907. This section of Lansdale on West Main Street from Green Street to Susquehanna Avenue represented the very center of the thriving borough. Looking west, the first building is First National Bank of Lansdale, built in 1875. The next building was the post office, followed by a building that contained a cigar store and bakery. Beyond these buildings is the Hotel Norwood and Freeds Hall. With the erection of these buildings, Lansdale was on its way to becoming a bustling and important community in Montgomery County. (Bartholomew postcard.)

THE FIRST NATIONAL BANK AND POST OFFICE, LANSDALE. As time went on, Lansdale's early buildings were being replaced by finer, more sophisticated structures, as seen here with the bank and post office. The original bank and post office were erected on West Main Street at Green Street in the 1800s. In 1911, this modern stone building was erected on the same site, with the bank and post office having separate entrances. (Bartholomew postcard.)

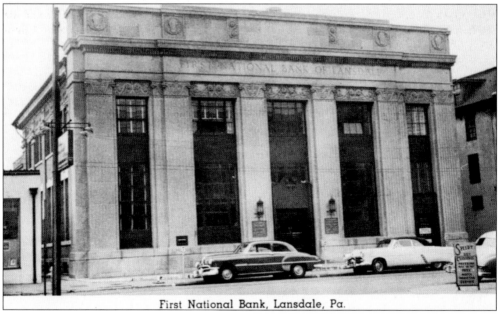

First National Bank, Lansdale, Pa.

THE FIRST NATIONAL BANK, LANSDALE. The continual evolution of the bank property is shown once again in this early-1950s view. The 1911 building was remodeled in 1929 into this handsome, Greek revival-style building. At this time, the post office moved around the corner to Broad Street. This building still serves as a bank but has changed names many times in the last few decades. (Art-Glo postcard.)

14

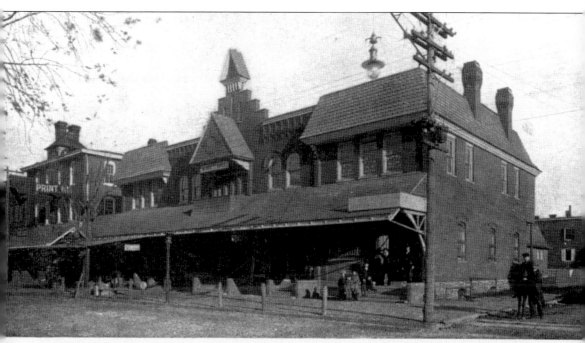

MUSIC HALL BLOCK AND CITIZENS' NATIONAL BANK, BROAD STREET, LANSDALE, PA.

THE MUSIC HALL BLOCK, LANSDALE, 1915. The Citizen's National Bank built the Music Hall Block on North Broad Street between Hudson and Second Streets. Built in 1889, the building housed a large concert hall, various stores, and the bank. Truly, Lansdale had arrived culturally. This postcard, published by Charles Berkemeyer, advertised where his postcards could be purchased. All his Lansdale views were sold at the Moyer Brothers store at Main and Walnut Streets. The Music Hall Block still stands and contains various businesses.

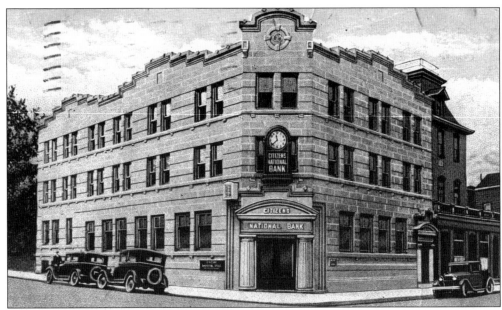

THE CITIZENS NATIONAL BANK. The Citizens National Bank had its origins in the Music Hall Block on North Broad Street in the 1880s. It moved into this building at West Main Street and Susquehanna Avenue, the former Hotel Norwood, *c.* 1920. The bank completely remodeled the old inn to the appearance shown in this view. This bank did not survive the Great Depression, and in later years the building's ground floor served as a food market. It was demolished in the 1990s.

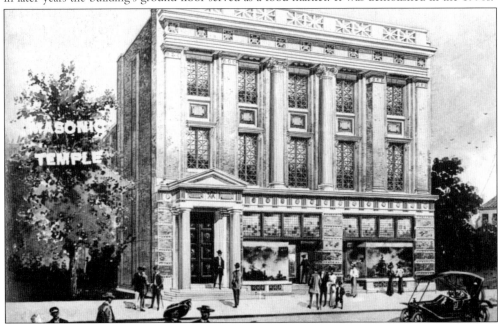

THE MASONIC TEMPLE, LANSDALE. One of Lansdale's oldest institutions is the Free and Accepted Masons, founded in 1882. After years of using other buildings, the Masons erected this temple on Main Street west of Susquehanna Avenue in 1913. This postcard could be a reproduction of the architect's rendering of the unique Greek-and Egyptian-style building, which still stands in Lansdale's business district.

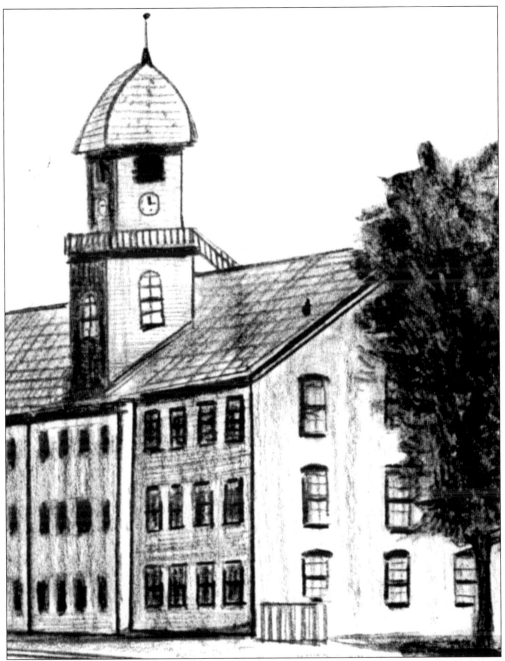

HEEBNER & SONS AGRICULTURAL WORKS. Lansdale's most successful and best-known industrial giant was the Heebner & Sons Agricultural Works, which was a pioneer in manufacturing agricultural equipment sold all over the world. The firm was established in 1872 by David Heebner and his sons, Isaac and William. This building was built on South Broad Street at the railroad in 1882. The landmark clock (with a bell tower) rang every hour and was referred to as Little Ben. William took over operations in 1887; he was also on the state legislature and responsible for a bill creating Valley Forge State Park. The plant closed in 1926 and was torn down in 1944.

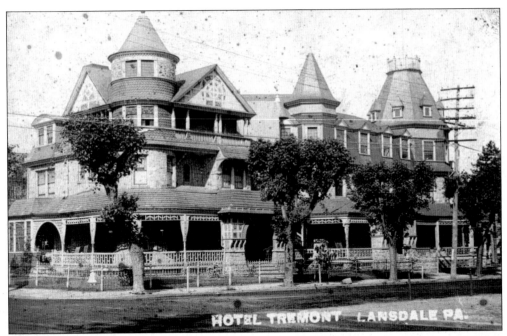

THE HOTEL TREMONT, LANSDALE. The centerpiece of old downtown Lansdale was the Hotel Tremont, also known as the Tremont Hotel, once located at the southwest corner of Main and Broad Streets. The hotel was established in 1893 in the building that was formerly the residence of Isaac Heebner. The hotel and restaurant operated for almost 100 years until it was demolished in the late 1990s for the creation of a drugstore. (Bartholomew postcard.)

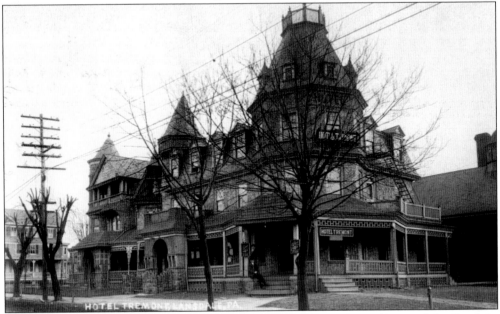

THE HOTEL TREMONT, 1914. This view from the west shows the architectural details of the Hotel Tremont, possibly Lansdale's most elaborate building. The original Heebner mansion was built in 1889 and sold in 1892 to A.G. Freed, who subsequently opened it as a hotel. An addition was made in 1893; it then became known as the Hotel Tremont. (Miller postcard.)

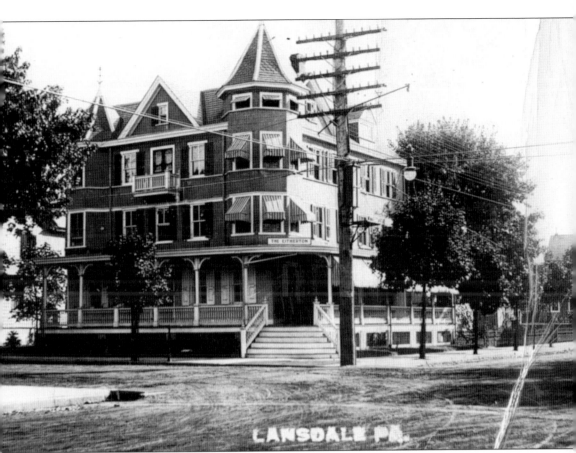

EITHERTON, LANSDALE. The Eitherton Boardinghouse and Hotel stood on the southeast corner of Broad and Main Streets. Built as a home for David Heebner in the late 1800s, it was adorned with turrets, balconies, and a porch. It stood near the boundary of Hatfield and Gwynedd Townships. Its name was derived from the fact that the building was situated in either town, causing it to be called Eitherton. The landmark building, which stood at Lansdale's busiest intersection, was torn down in 1964 and replaced with a gas station. (Bartholomew postcard.)

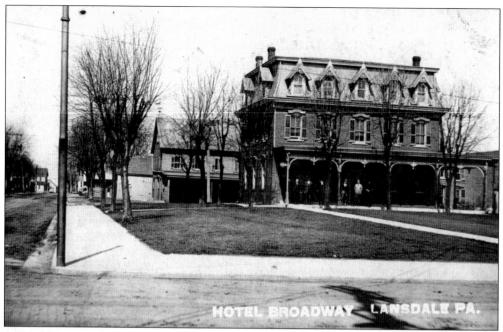

THE HOTEL BROADWAY, LANSDALE. The Hotel Broadway was built in 1888 and stood adjacent to the railroad on Broad Street at the corner of Vine Street. The Victorian building was constructed of brick with a mansard roof and gothic-style window woodwork. Later, the post office, which is now borough hall, was built on this site. (Bartholomew postcard.)

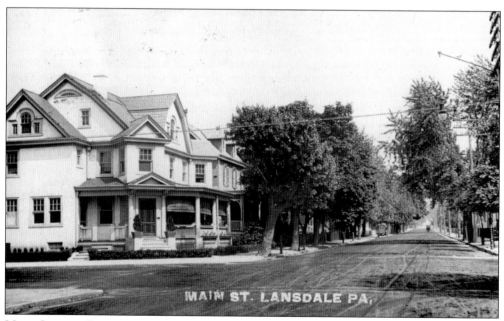

MAIN STREET, LANSDALE, 1914. Standing at the corner of Broad and Main Streets looking east were a series of large, well-kept homes. The home on the corner was owned by Dr. Herbert Moyer. This, along with several others, was torn down as Lansdale's business district expanded. (Bartholomew postcard.)

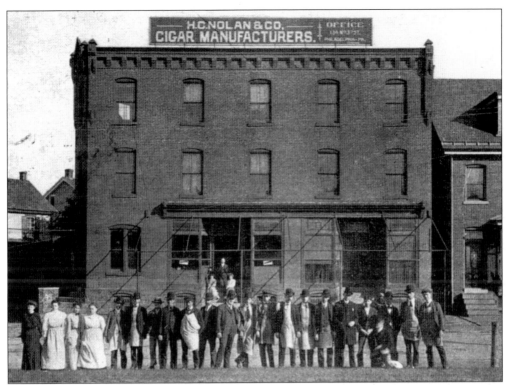

H.C. NOLAN & COMPANY, CIGAR MANUFACTURERS. Postcard views made by Charles Berkemeyer are noted for their scenes showing commercial buildings with their employees standing in the foreground. Perhaps Berkemeyer was attempting to show that employees are as important as the factory buildings in which they worked. H.C. Nolan & Company produced cigars, a familiar trade in this region in the early 1900s. This building still stands at Second and Walnut Streets, opposite the railroad.

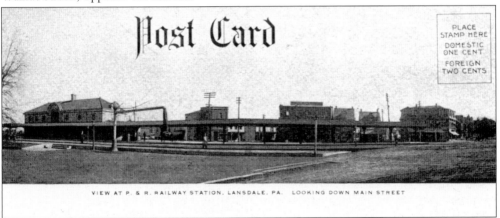

THE RAILWAY STATION, LANSDALE. Charles Berkemeyer of Sellersville published many postcards of Sellersville, Perkasie, and Lansdale. His views were unique because he placed scenes on the reverse or address side of his cards. His Lansdale views all appear to have an image of the train station looking down Main Street. The railroad station is shown on the left, followed by H.C. Nolan & Company in the center, and Moyer Brothers General Store on the right. This block is still intact today, occupied by stores.

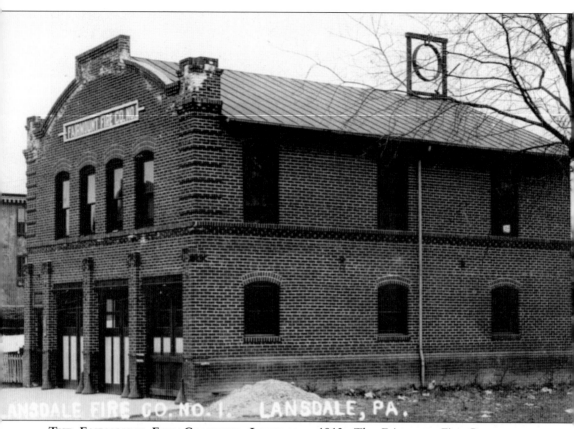

THE FAIRMOUNT FIRE COMPANY, LANSDALE, 1912. The Fairmount Fire Company was founded in 1889, the same year that the borough leased a small building on Courtland Street and Montgomery Avenue as the first firehouse. In 1890, the first firehouse was built at Derstine and Wood Streets. Quickly outgrowing that building, in 1900, they built a bigger firehouse at Susquehanna Avenue and Courtland Street, which is the building pictured in this rare view. With the borough's population growing, a large, five-bay firehouse was built at Susquehanna Avenue and Derstine Street. Since 1980, the Fairmount Fire Company has been located at Vine Street and Susquehanna Avenue. (Miller Postcard.)

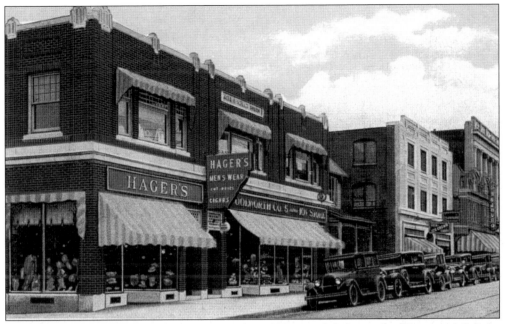

THE HAGER AND SCHULTZ BUILDING. This 1920 postcard shows the Hager and Schultz building on the north side of Main Street at Wood Street. Merchant William Hager and real estate owner and accountant Harry Schultz teamed up to construct this building, which was also the home to Lansdale's Woolworth store for over 50 years. This building is still standing and is occupied by businesses.

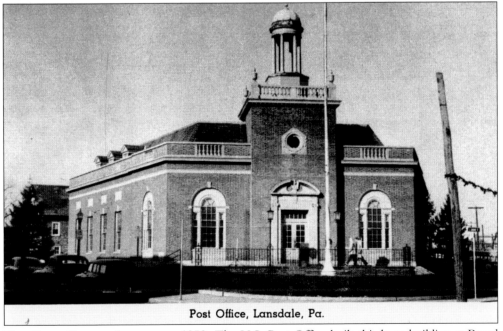

Post Office, Lansdale, Pa.

THE POST OFFICE, LANSDALE, 1952. The U.S. Post Office built this large building at Broad and Vine Streets in the 1930s. In 1988, the post office moved to new facility across Vine Street, and this building became Lansdale Borough Hall. (Art-Glo postcard.)

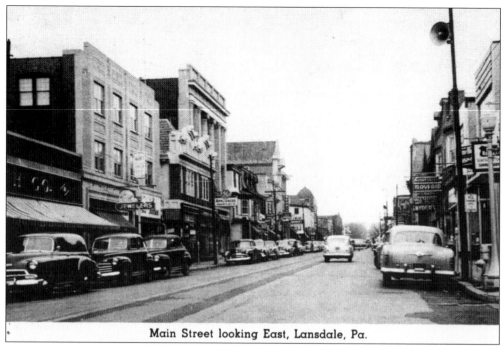

Main Street looking East, Lansdale, Pa.

MAIN STREET LOOKING EAST, LANSDALE, 1952. In the 1950s, Lansdale's business district was bustling with a wide variety of shops. This scene on West Main Street looking east from Wood Street shows the Woolworth store on the extreme left. Also shown are the Masonic Temple and other small stores. (Art-Glo postcard.)

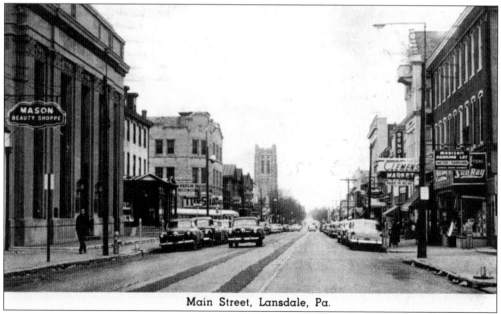

Main Street, Lansdale, Pa.

MAIN STREET, LANSDALE, 1952. Many people still have fond memories of spending time shopping on Main Street in Lansdale in the 1950s. Looking west into the heart of the business district are SunRay Drugs, Clemens Market, and Mason Beauty Shoppe. In the distance is the tower of St. John's Reformed Church. (Art-Glo postcard.)

24

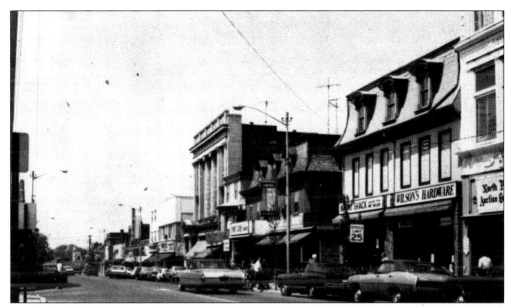

MAIN STREET, LANSDALE. This early-1970s view shows the 200 Block of West Main Street, above Green Street. Looking west, the shops are Wilson's Hardware, which is still in existence, and the storefront that today houses Spice Smuggler, which was preceded by the Lansdale News Agency. The large Masonic Temple stands in the middle of the block. The 1977 opening of the Montgomery Mall drew many away from Main Street. (Merrimack postcard.)

THE LANSDALE PUBLIC LIBRARY, 1974. The Lansdale Library Association was founded in 1928 and had its first library in the old borough hall on Courtland Street. In 1958, the first library building was erected at Vine Street and Montgomery Avenue. In 1972, the library moved to its present location, Vine Street and Susquehanna Avenue, as seen in this view. In the 1990s, changes were made to this building. (Merrimack postcard.)

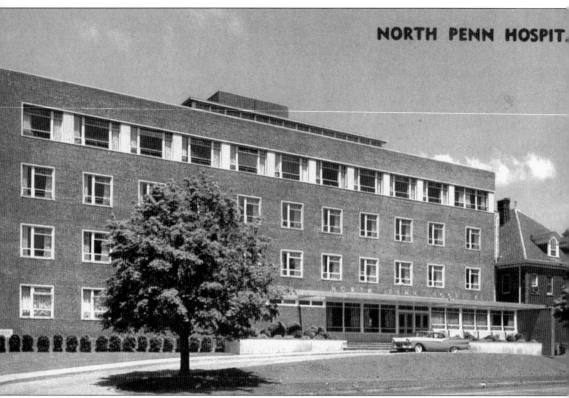

THE NORTH PENN HOSPITAL, 1960. Founded in 1934 and originally called Elm Terrace Hospital, the facility was originally located in two residences at Seventh and Broad Streets. The hospital experienced a rapid increase in admissions through the 1940s and 1950s. Changes occurred in 1953, when its name was changed to North Penn Hospital. In 1955, this new, brick, four-story building was built. It is shown alongside of the old Jonathan Zane house, an original part of the early hospital that was later torn down. In later years, the hospital relocated to a site off of North Broad Street, and this building became a nursing home.

Two
LANSDALE RESIDENCES

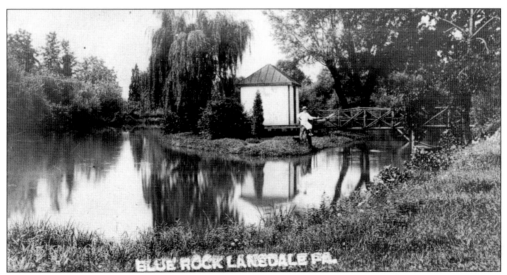

THE BLUE ROCK ESTATE. Besides being a bustling place with busy railroad lines running through the center of town, Lansdale had tranquil places of scenic beauty, like the Blue Rock Estate east of town. Reflections are captured on this postcard by John Bartholomew from 1905.

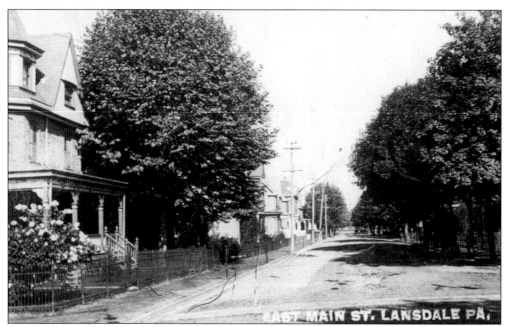

EAST MAIN STREET. Homes with large shade trees dominated much of residential Lansdale in the early 1900s. Here is Main Street looking west from the corner of Chestnut Street. The Victorian home on the left still stands on this very busy stretch of road. (Bartholomew postcard.)

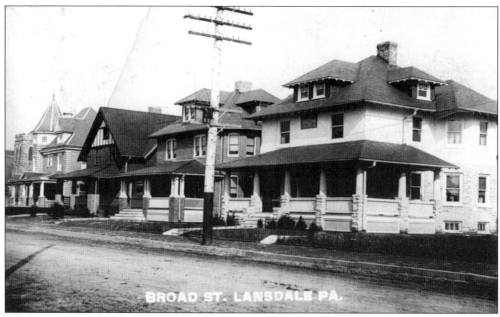

BROAD STREET, EAST SIDE. Varying architectural styles seem to dominate Broad Street and other sections of Lansdale. This view shows the east side of Broad Street between Third and Fourth Streets. At the corner of Fourth Street is the Lansdale Methodist Church. All buildings shown here are still standing. (Bartholomew postcard.)

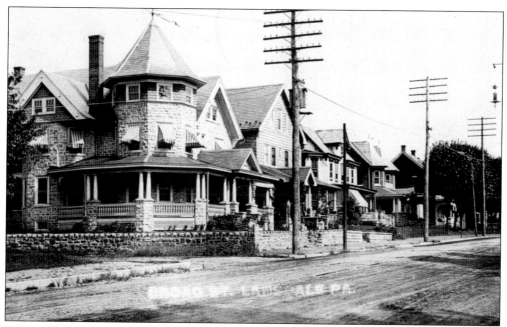

BROAD STREET, 1910. Both Broad and Main Streets in Lansdale are lined with some of the borough's most elaborate homes, many owned by successful merchants and industrialists. This stone Victorian home, complete with an octagonal tower and wraparound porch, stands at the northwest corner of Broad and Mount Vernon Streets. (Bartholomew postcard.)

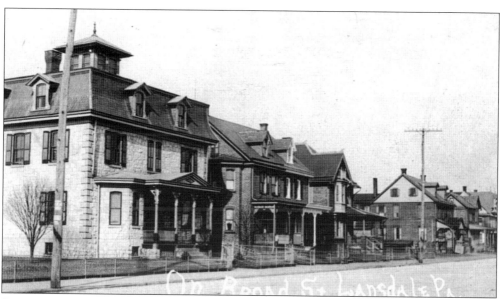

BROAD STREET. More and larger homes line North Broad Street at Fifth Street. Fashionable Broad Street homes seem to outdo each other. The home on the left has stone work, a mansard roof, and what appears to be a unique widow's walk or tower on the roof. This home is still standing. (Bartholomew postcard.)

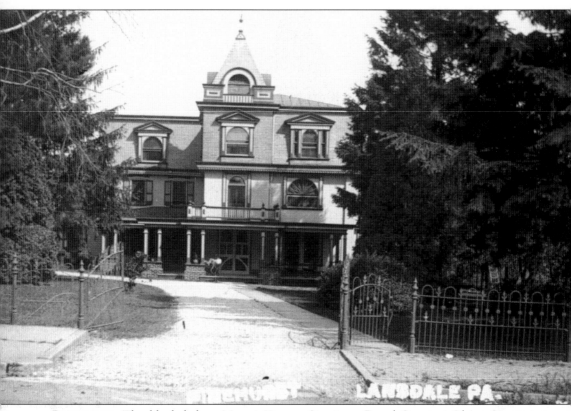

PINEHURST. The block below Mount Vernon Street on Broad Street at Blaine Street was once home to Pinehurst, the estate of John Krupp. A central spire and large, oddly shaped windows with wood trim make this home very unique. Krupp was co-owner of a foundry business in Lansdale. He died at the age of 45 in 1925. This home is no longer standing. (Bartholomew postcard.)

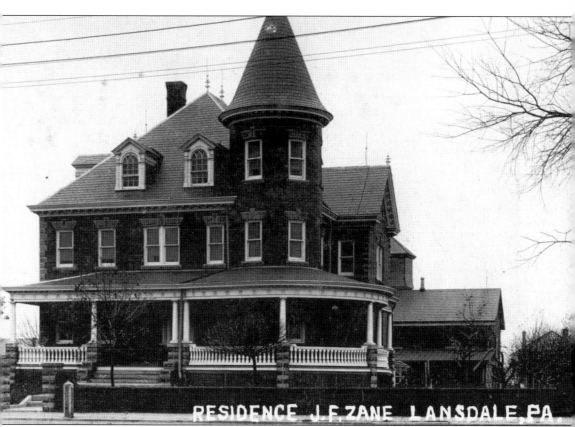

THE RESIDENCE OF J.F. ZANE. Jonathan Zane owned Lansdale's best-known bakery, located on West Main Street above Green Street. As with most cases, successful merchants built lavish homes, and Zane was no exception. His mansion, once located on Broad Street at Seventh Street, was one of Lansdale's largest homes. In later years, it housed Elm Terrace Hospital. Eventually, North Penn Hospital built a large building to the south of this home, and the Zane home was torn down. (Miller postcard.)

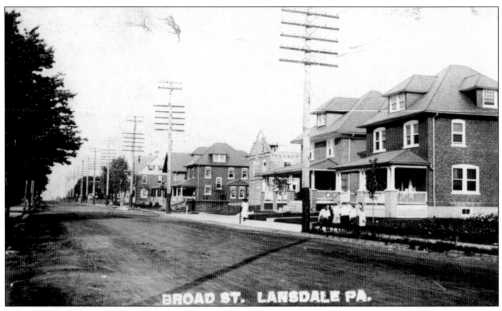

BROAD STREET, EARLY 1900s. New residences were sprouting up along sections of North Broad Street in the early 1900s. North of Third Street, Broad Street was mainly residential. (Bartholomew postcard.)

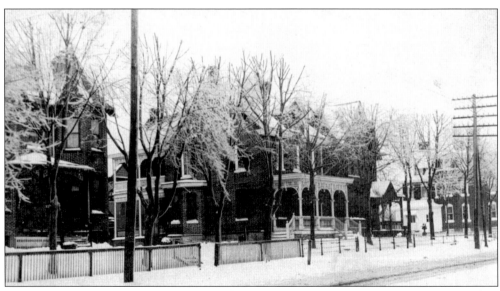

ALONG BROAD STREET. Stately Victorian homes are set amid snow and ice in this rare look at a Lansdale winter storm in 1905. (Bartholomew postcard.)

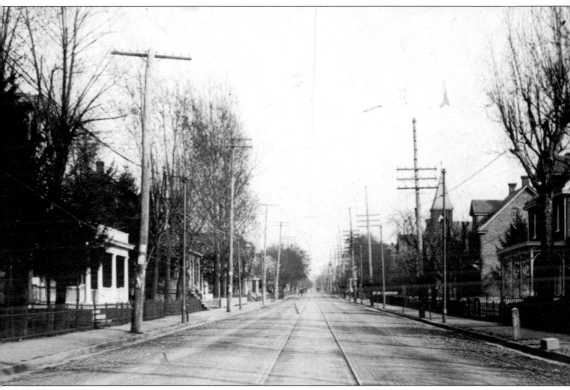

MAIN STREET. An empty West Main Street is shown *c.* 1910, with trolley tracks located in the middle of the road. This scene is looking east from near Towamencin Avenue, with the spire of the old St. John's Reformed Church shown on the right. (Bartholomew postcard.)

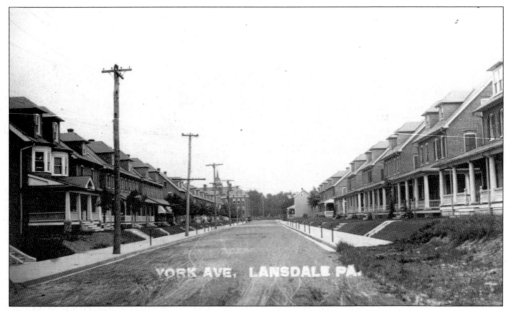

YORK AVENUE. Newly constructed homes from 1910 are shown on York Avenue looking east from Richardson Avenue toward Green Street. In the distance to the left is the Green Street School. Most homes on this block are still standing. (Bartholomew postcard.)

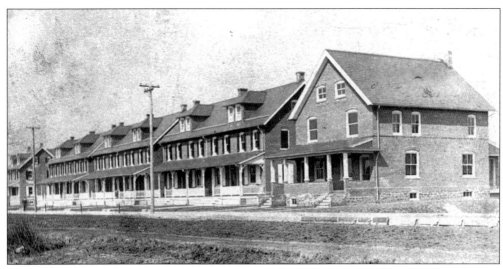

YORK AVENUE. York Avenue is shown in 1910 with newly constructed homes west of Green Street, indicating the growth that was occurring in Lansdale at that time. (Bartholomew postcard.)

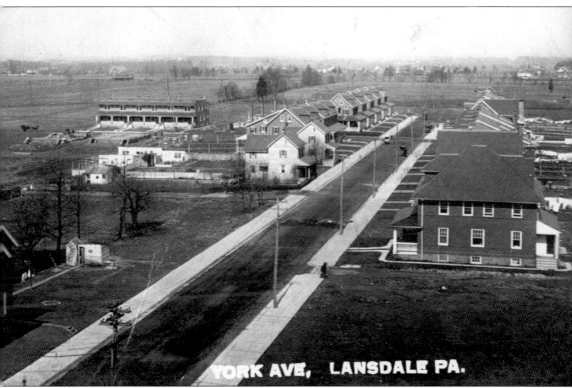

YORK AVE, LANSDALE PA.

YORK AVENUE, 1910. What to some might appear to be an ordinary postcard view in reality involved quite an effort. In this case, photographer John Bartholomew climbed up onto the roof of the Green Street School and set up his camera to take this extraordinary view of York Avenue looking west from the school. What he saw were newly constructed homes on unfinished streets with plenty of open space. This image offers the viewer a fascinating glimpse of Lansdale's growth.

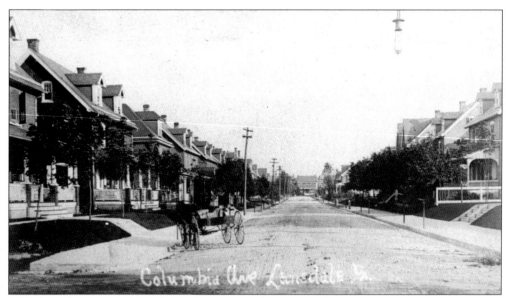

COLUMBIA AVENUE. One lone horse-drawn wagon is the only mode of transportation found on Columbia Avenue looking east from Towamencin Avenue toward Green Street. This residential street is still intact. (Bartholomew postcard.)

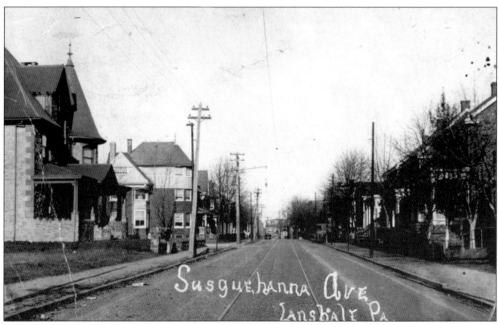

SUSQUEHANNA AVENUE, 1906. Handsome homes line Susquehanna Avenue in this view looking north toward Main Street in the distance. (Bartholomew postcard.)

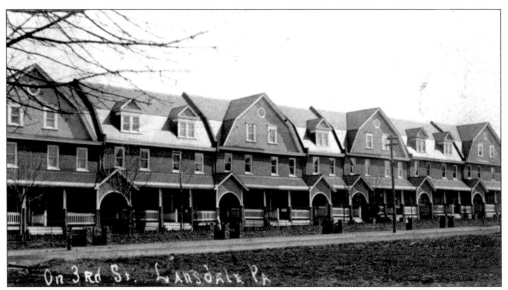

ON THIRD STREET. New, neatly built row homes are shown in 1908 on the north side of Third Street east of Chestnut Street. Note that the south side of the street had not been built up at this time. Row homes such as these were built for labor workers employed by many of Lansdale's new industries. (Bartholomew postcard.)

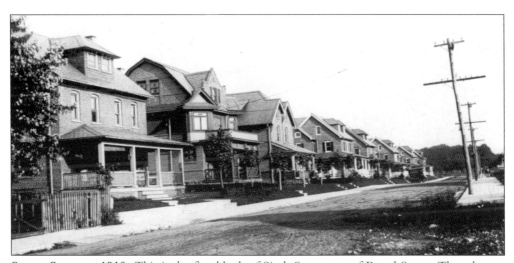

SIXTH STREET, 1910. This is the first block of Sixth Street east of Broad Street. These homes still stand. (Bartholomew postcard.)

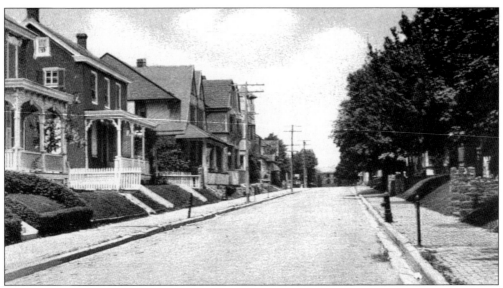

A VIEW OF GREEN STREET. This view shows Green Street looking north from York Avenue. The homes shown in this 1910 view still stand. Remarkably, the brick house on the extreme left retains its Victorian porch. Main Street is seen at the end of the street. (A.H. Landis, Lansdale, postcard.)

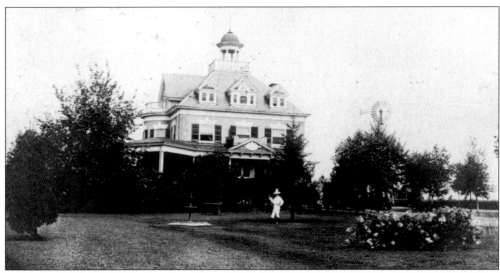

BLUE ROCK, 1910. The stately Blue Rock Mansion and its spacious grounds were developed in 1895 by Theodore Weidman (1861–1917). He was a very successful oil merchant. Blue Rock occupied a site on the north side of East Main Street, along the Wissahickon Creek. The house is no longer standing. (Bartholomew postcard.)

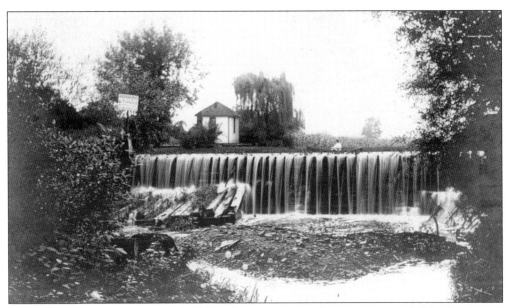

BLUE ROCK, 1910. Theodore Weidman's gracious mansion was surrounded by landscaped grounds bordering the Wissahickon Creek. A small dam along the creek created a lake, perfect for boating and other country pleasures. Some of this property near the creek has been incorporated into Wissahickon Park in Lansdale Borough. The dam and pond are gone. (Bartholomew postcard.)

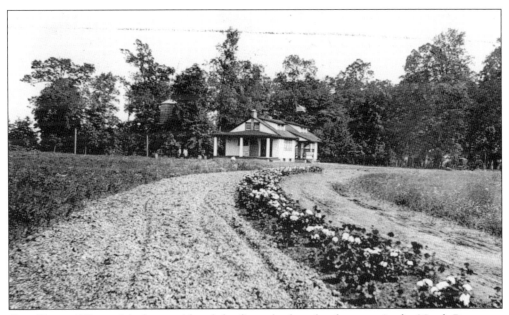

OAK PARK. What might be considered the first suburban development in the North Penn area is that of Oak Park, which occupies a site on West Main Street and Welsh Road just outside the borough boundaries. Oak Park was developed by Harry Richardson, a builder from Lansdale, in 1912. The curving streets and single homes still exist in Oak Park. (Bartholomew postcard.)

THE JENKINS HOMESTEAD. This home might be Lansdale's oldest building and is one of a few farm-style buildings in town. The Jenkins deed to the land where the home stands can be traced to 1795. Today, this structure is home to the Lansdale Historical Society, which lovingly operates a museum and research library. It is well worth a visit to this old landmark, which is open to the public on Wednesday afternoons and Saturday mornings. It is located on 137 Jenkins Avenue.

Three
LANSDALE SCHOOLS, CHURCHES, AND PARKS

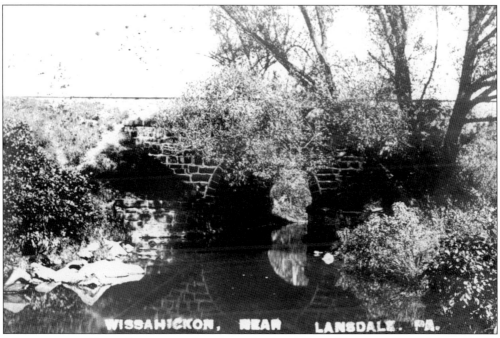

WISSAHICKON, NEAR LANSDALE. Summer reflections of an old stone railroad bridge on the Wissahickon are preserved on this John Bartholomew postcard dated July 23, 1907. The message on the postcard states, "We pass this going to my aunt's."

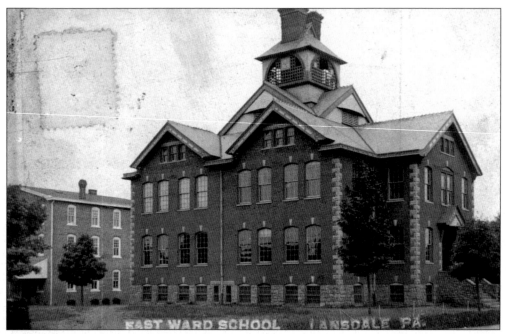

THE EAST WARD SCHOOL. This eight-room schoolhouse was built in 1887 at Third and Broad Streets in what was to be called the Broad Street School or East Ward School. Costing $16,500, it was an ambitious project for the young borough. The first graduating class from this school was in 1888. The building no longer stands. (Bartholomew postcard.)

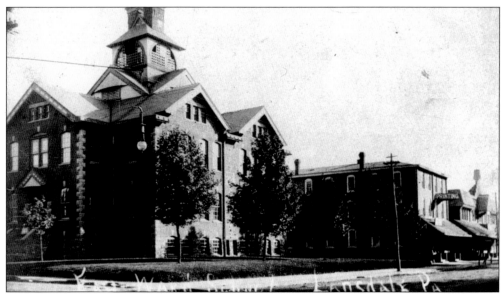

THE EAST WARD SCHOOL, 1905. Looking south on Broad Street from Third Street is the East Ward School (Broad Street School). Next to the school were businesses, including a printing office, and on the extreme right is the Music Hall Block. Broad Street contained a variety of buildings all close to one another. These included the school, businesses, and homes. (Bartholomew postcard.)

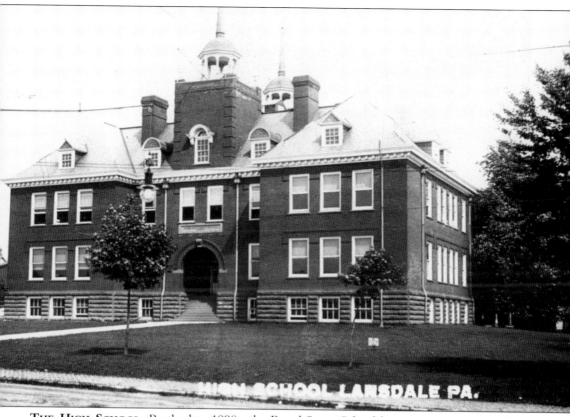

THE HIGH SCHOOL. By the late 1890s, the Broad Street School became very crowded. The result was the construction of the Green Street School (West Ward School) in 1900. Within a few years, this building became the high school for the borough. Located at York Avenue and Green Street, the school is no longer standing. (Bartholomew postcard.)

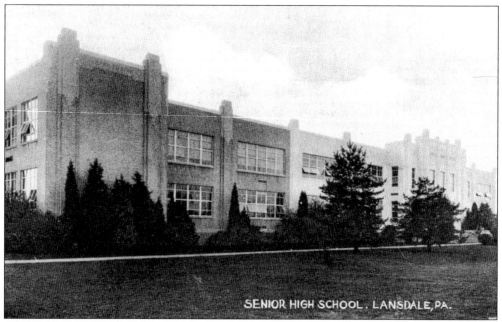

SENIOR HIGH SCHOOL . LANSDALE, PA.

THE SENIOR HIGH SCHOOL. What is today's Penndale Middle School, established in 1971, was originally built as Lansdale High School. Built in 1931 at Penn and Church Streets, the original building is shown *c.* 1950, prior to the many additions and alterations. The left side of the building with the darker brick was completed in 1937.

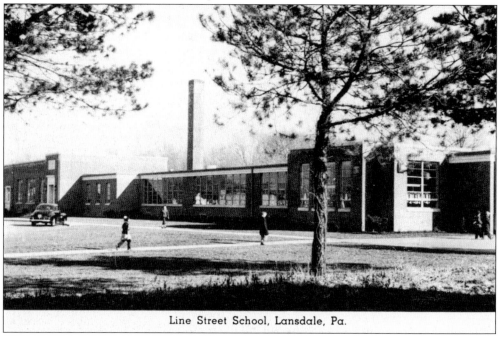

Line Street School, Lansdale, Pa.

THE LINE STREET SCHOOL, 1952. The Line Street School was built in 1951 and opened in 1952, about the time this postcard was made. Changing and aging student populations caused the school to close in 1979. Located on Line Street at Fourth Street, the building still stands, but is used as a religious facility. (Art-Glo postcard.)

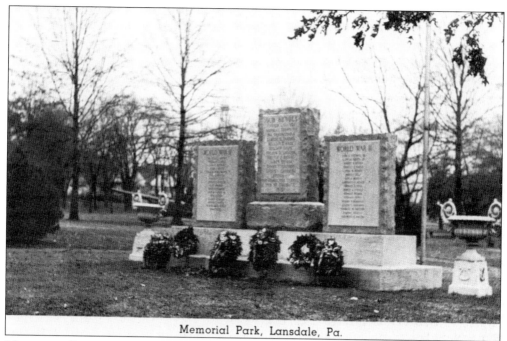

Memorial Park, Lansdale, Pa.

MEMORIAL PARK, 1952. Memorial Park, located at East Main and Line Streets, was established after World War I to honor soldiers from Lansdale. Shown in this view are monuments of several wars that can still be seen today. Today, there are additional monuments honoring Vietnam Veterans. The 10-acre park contains large trees, walkways, and benches. (Art-Glo postcard.)

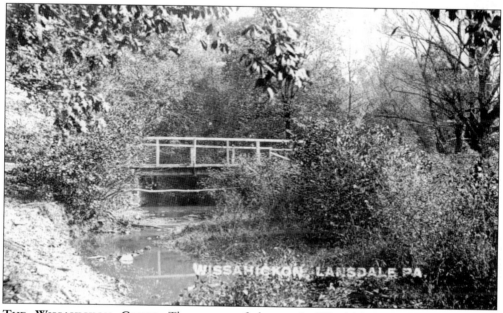

THE WISSAHICKON CREEK. The source of the scenic Wissahickon Creek is a series of underground springs and small ponds in the vicinity of Lansdale. There are a number of postcard views that show glimpses of the Wissahickon, usually near a rustic bridge, as seen in this 1910 view. (Bartholomew postcard.)

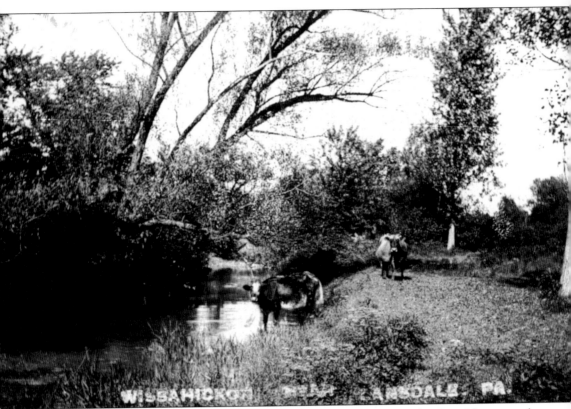

THE WISSAHICKON CREEK, NEAR LANSDALE. Beginning in the Lansdale area, the Wissahickon Creek flows south through much of eastern Montgomery County before entering Philadelphia's Fairmount Park and emptying into the Schuylkill River. In this 1910 view, a few meandering cows cool off by the inviting stream on a summer day. This view illustrates the country life of the North Penn area years ago. (Bartholomew postcard.)

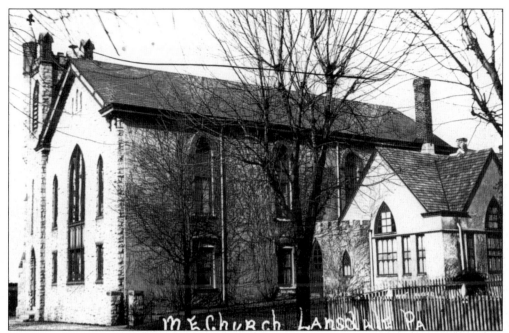

THE METHODIST EPISCOPAL CHURCH. This is the original building of the Lansdale Methodist Episcopal Church. Built in the early 1870s, this was Lansdale's first church. This building still stands at Third and Walnut Streets, but its appearance is altered. It has been used for other purposes since 1919, when the Methodists built a church down the block at Third and Broad Streets. (Bartholomew postcard.)

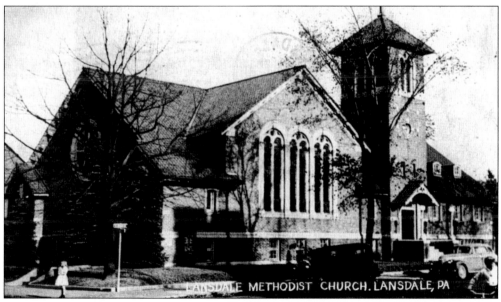

THE LANSDALE METHODIST CHURCH, C. 1948. Located on the west side of Broad Street at Third Street is the Lansdale Methodist Church. It was founded in 1871 as a branch of the Montgomery Square Methodist Church. This is the church's second home, built in 1919. Additions have been made from the 1930s through the 1960s.

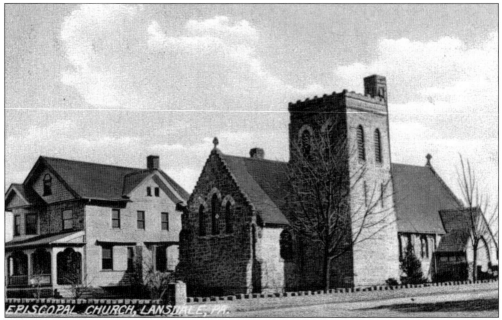

THE EPISCOPAL CHURCH, 1915. Holy Trinity Episcopal Church was built in the late 1890s at North Broad and Fourth Streets. Through the decades, changes and additions have occurred, though in this view it looks quite similar to today.

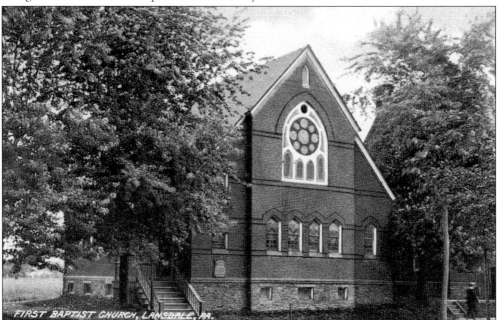

THE FIRST BAPTIST CHURCH AND BETH ISRAEL SYNAGOGUE BUILDING. In Lansdale, many religious institutions moved as they grew in size. This small gothic church was built in 1884 on Third Street at Broad Street and was known as the First Baptist Church. The church expanded in 1910 and 1920. In 1954, a new church was built at Eighth and Broad Streets. The building to the right is still standing and, for a time after the church was vacated, Beth Israel Synagogue occupied this building.

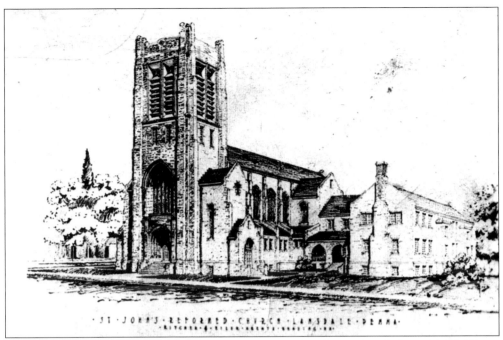

ST. JOHN'S REFORMED CHURCH. St. John's United Church was founded in 1876. Different church buildings were constructed throughout the 1800s and 1900s. This postcard shows the architects' original design for the present church, built in 1953. St. John's Reformed Church, at 500 West Main Street, is one of Lansdale's most prominent buildings.

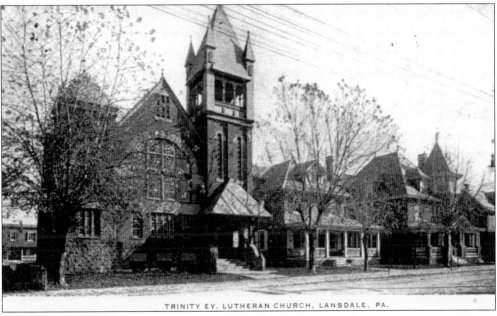

TRINITY LUTHERAN CHURCH. Trinity Evangelical Lutheran Church was founded in 1881. This church was first built in 1891 on the north side of East Main Street below Broad Street. In 1956, the church moved to its present location at West Main Street at Valley Forge Road. This old church building is no longer standing. (Berkemeyer postcard.)

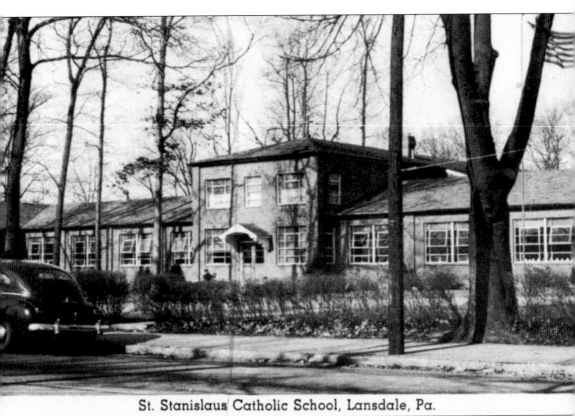

St. Stanislaus Catholic School, Lansdale, Pa.

ST. STANISLAUS CATHOLIC SCHOOL AND CHURCH, 1952. St. Stanislaus Catholic Church was founded in 1876 as a branch of Our Lady of Mount Carmel in Doylestown. The school was established in the 1890s. This school building on East Main Street at Church Street was built in 1949. There were additional school and parish buildings added through the decades. Today, St. Stanislaus is an active school and church in the North Penn area. (Art-Glo postcard.)

Four

THE NORTH WALES
BUSINESS DISTRICT

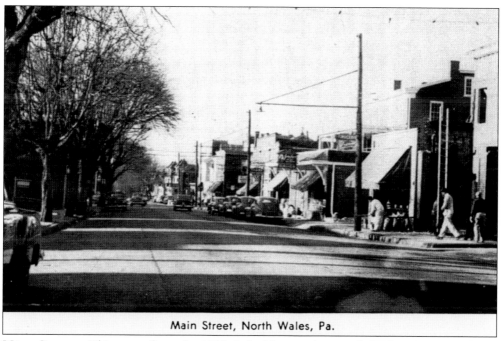

Main Street, North Wales, Pa.

MAIN STREET. This scene from the 1950s is looking north towards Walnut Street. Today, a pharmacy, florist, hardware store, several eateries, and insurance and real estate offices occupy North Wales's Main Street business district. (Seeman postcard.)

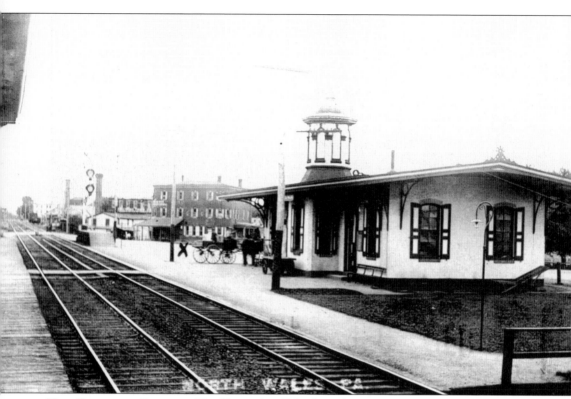

THE RAILROAD STATION. The Borough of North Wales was incorporated in 1869. A small village existed years earlier on the Sumneytown Pike at North Wales Road. The village name is derived from the Welsh population that settled the Gwynedd area. In 1857, the North Pennsylvania Railroad extended their line through the village and a station was built at Main Street and Montgomery Avenue. In 1873, this station was built at Walnut and Fifth Streets. This John Bartholomew image clearly shows the tracks' path through the town. The station was vital to the growth of North Wales. Today, the station continues to operate as a link for commuters to Philadelphia.

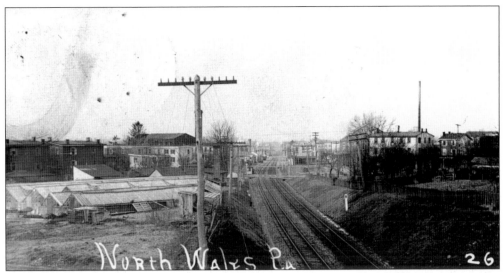

THE RAILROAD, 1906. The North Pennsylvania Railroad built a diagonal path through North Wales, crossing many of its streets. Oddly, only one bridge on Pennsylvania Avenue exists over the tracks. In 1901, a trolley line was extended up Sumneytown Pike into North Wales. The trolley line was diverted around the railroad crossing on Main Street onto the Pennsylvania Avenue bridge. The railroad was important to the growth of the borough, with many businesses located near its tracks. Some the businesses included Shearer Lumber in 1862, Weingartner Cigars in 1891, and Florex Gardens in 1907. (Bartholomew postcard.)

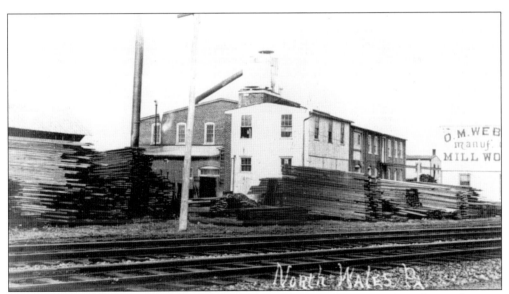

WEBER MILL WORK. Tiny North Wales had a surprisingly large number of manufacturing companies in its early days. By the 1880s, in addition to the railroad station, post office, and several hotels, businesses such as A.K. Shearer Lumber Yard, North Wales Marble Works, Steam Roller Mills, and various other enterprises were established. This view shows the O.M. Weber Mill Work manufacturers along the railroad in North Wales. (Bartholomew postcard.)

MAIN STREET. This 1910 view shows the east side of North Main Street north of Walnut Street. The buildings close to the corner have long been replaced, their spots presently occupied by a bank and hardware store. The homes to the left side of this view are still standing. (Bartholomew postcard.)

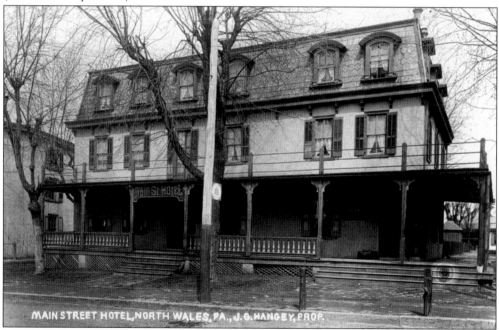

THE MAIN STREET HOTEL, 1915. The Main Street Hotel is one of North Wales's oldest buildings and dates from the mid-1800s, when it was an inn on the old Sumneytown Pike. In the early 1900s, J.G. Hangey was the proprietor. The old hotel had a porch, fine woodwork, and a mansard roof. Today, the building is located at 123 South Main Street and retains some of the old features, including the roof and dormers, but gone are the porches and railings. It is presently occupied by offices. (Miller postcard.)

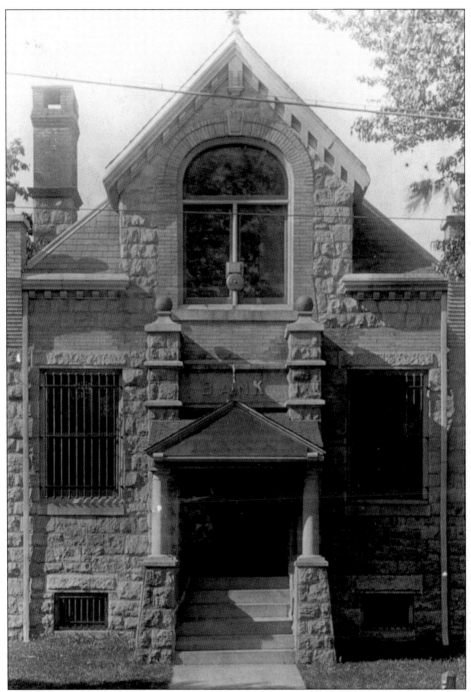

THE NATIONAL BANK, 1910. In the late 1800s to the early 1900s, almost every small town had a bank on its main street, and North Wales was no exception. Dating from the late 1800s, the North Wales National Bank on North Main Street was a rather small building. Dominated by large cut stones, the vault-like structure symbolized the strength and security the bank offered its customers. Other banks through the years occupied the building until 1980. Presently, the building is occupied by offices. (Miller postcard.)

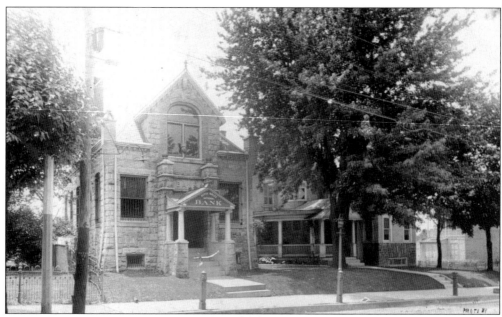

THE NORTH WALES NATIONAL BANK, 1908. The North Wales National Bank occupied a site on North Main Street amid tall shade trees and Victorian residences. The borough had a tranquil appearance in its early days. This bank was one of only a few that did not fail during the Great Depression. (Sliker postcard.)

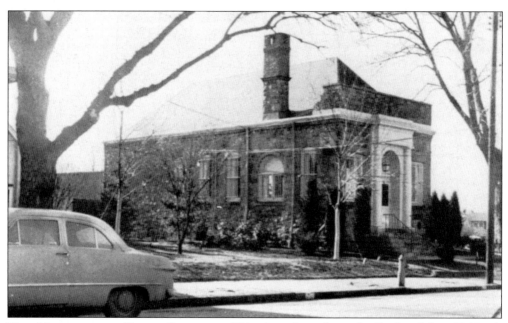

THE MONTGOMERY TRUST COMPANY. This view shows how the facade of the old North Wales National Bank had been altered over the years. At the time this 1952 view was made, the building was occupied by the Montgomery Trust Company. (Seeman postcard.)

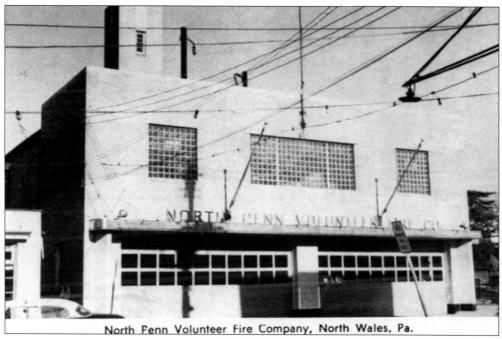

North Penn Volunteer Fire Company, North Wales, Pa.

THE NORTH PENN VOLUNTEER FIRE COMPANY, 1952. This fire company was organized in 1928. This building was constructed in 1949 on South Main Street at the railroad crossing. The active fire company and building continue to serve the community. (Seeman postcard.)

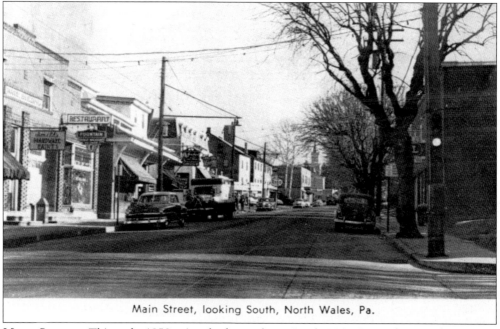

Main Street, looking South, North Wales, Pa.

MAIN STREET. This early-1950s view looks south on South Main Street from Walnut Street. Many of these businesses still thrive, although others have changed through the years. In 2000 and 2001, new brick walkways and colonial-style street lights have enhanced the small-town image of the borough. (Seeman postcard.)

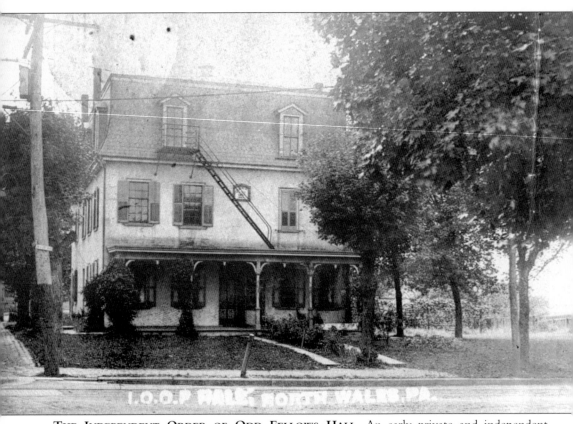

THE INDEPENDENT ORDER OF ODD FELLOWS HALL. An early private and independent society was the Independent Order of Odd Fellows. The North Wales lodge was founded in 1867, several years prior to the borough's incorporation. The Odd Fellows were described as patriotic and charitable, with respect for fellow man and God. Their hall, built in the late 1800s at Main and Elm Streets, is no longer standing. (Bartholomew postcard.)

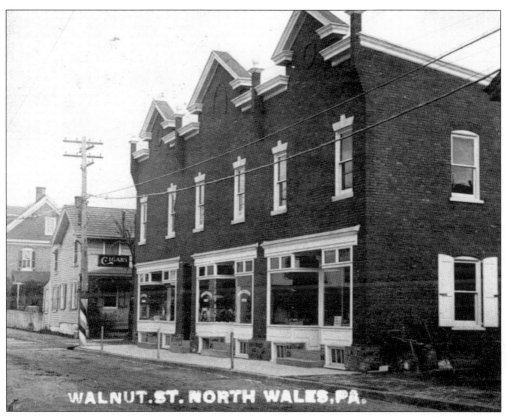

WALNUT STREET, NORTH WALES. Between the railroad and Main Street, Walnut Street contained many businesses, rivaling the commercial district on Main Street. Looking east on Walnut toward Third Street is a group of three stores. Nearest to Third Street is a store selling cigars. Next to the cigar store is a store identified by the name Rorer on the window. This row still stands, though the roofline has been flattened with the pointed tops removed. (Bartholomew postcard.)

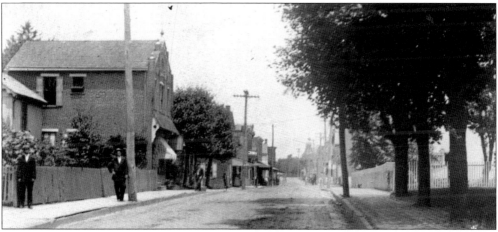

WALNUT STREET, NORTH WALES, 1908. This view is looking east on Walnut Street from Main Street to Second Street and beyond. The large building on the left was the post office for the borough. It is presently occupied by a business. (Sliker postcard.)

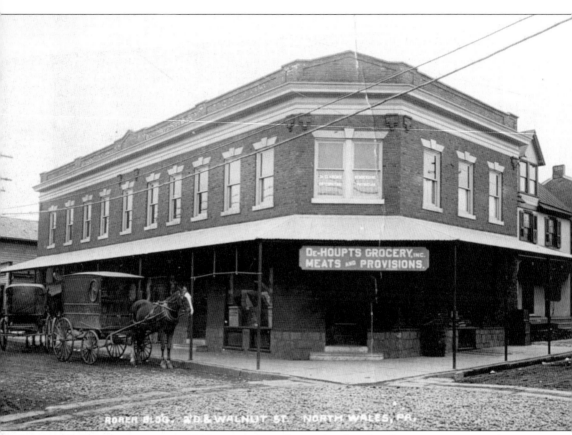

THE RORER BUILDING, 1915. Located on the south side of Walnut Street at Second Street is this commercial building, which originally housed De Houpts Grocery. The second floor contained the offices of Dr. Clarence Kenderdine, an osteopathic physician. On Walnut Street are several horse-drawn wagons. The one with the horse appears to be the De Houpts delivery carriage. This is an outstanding view of a local tradesman's establishment in North Wales. Today, the building still stands with its familiar facade and houses a restaurant. It is possible that this building housed a studio for postcard photographer W.W. Miller, since some of his postcard backs state, "W. Miller, commercial photographer, Rorer Building, North Wales, Pa." (Miller postcard.)

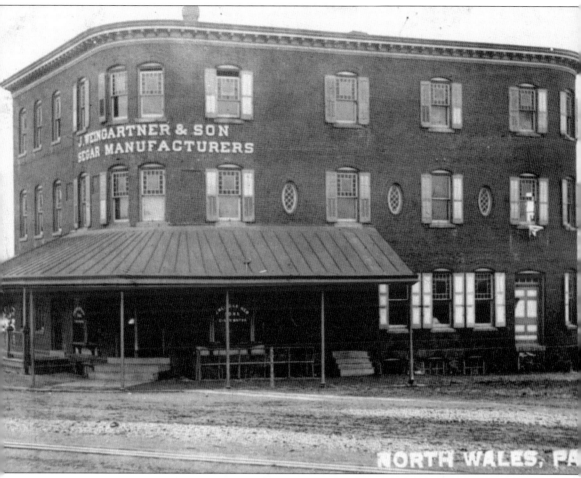

Weingartner and Son Cigar Manufacturer, 1909. J. Weingartner was producing cigars in the 1870s in North Wales and, as the business grew, this building was erected in the 1890s. Conveniently located on Walnut Street at the railroad, the first floor served as a retail store for the business. Cigar manufacturing was a thriving industry in the North Wales, Lansdale, and Sellersville areas during the 1800s and early 1900s. The building still stands and serves as a news agency. (Bartholomew postcard.)

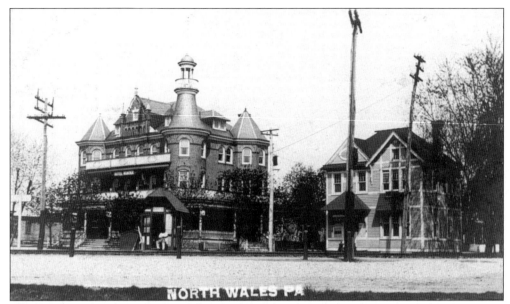

THE HOTEL WUNDER, 1905. The largest inn located in North Wales, the Hotel Wunder, began in 1893 as the Colonial Hotel, located on Walnut Street opposite the train station. In the early 1900s, it was owned by Horace Wunder, who changed its name to his namesake. Through the years, it has served under many different owners. In front of the hotel is the railroad watchman's guardhouse. The building to the right was originally used for a hay and grain business. (Bartholomew postcard.)

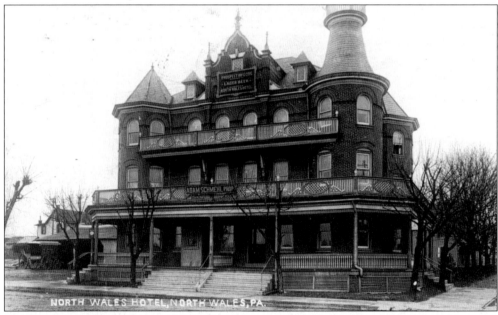

THE NORTH WALES HOTEL, 1918. Adam Schmehl purchased the hotel in 1910, and its name was changed to the North Wales Hotel. As seen in this closeup view, the building was very large and ornate, complete with turrets, finials, and a porch on each of the three floors. The building still stands, and its overall design is still intact, but many of the details and features have been removed. (Miller postcard.)

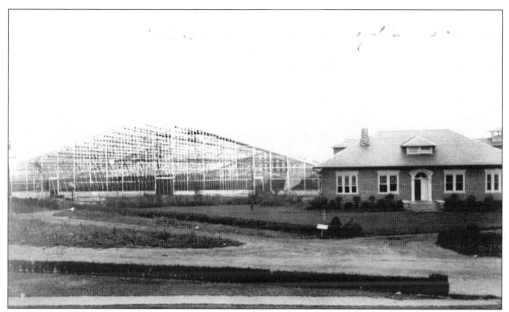

THE FLOREX GARDENS. The Florex Gardens once stood directly north and just outside of the borough boundary. Located along the railroad at Beaver Street and Wissahickon Avenue, the garden and greenhouse operation was started in 1907 and was in business for a half century. This 1910 view shows the brick office alongside one of the giant greenhouses. (Bartholomew postcard.)

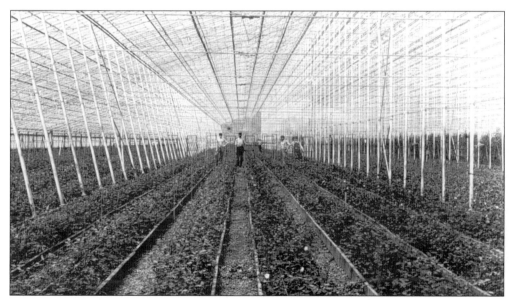

THE ROSE HOUSE, FLOREX GARDENS. Florex was reputed to have the largest greenhouses in the world. In this view is a glimpse of the immense rose house, with acre upon acre of roses surrounded by hundreds of panes of glass. The few workers shown here are almost lost in rows of flowers and trusses. (Miller postcard.)

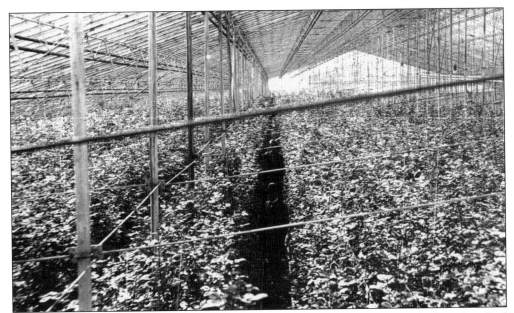

THE FLOREX GARDENS. The enormity of the Florex Gardens operation can be best described by the message found on this postcard. It reads, "Largest greenhouses in the world covering four acres under glass in one house, cut 30,000 rose buds in one days cutting. One house over 700 feet long with 80,000 rose bushes, about 140,000 all told, 3,000 to 4,000 ferns, 35,000 to 40,000 carnations." Today, nothing survives of this once immense business. (Bartholomew postcard.)

MAIN STREET, NORTH WALES. Looking south on Main Street from Elm Street are homes built at different times with varying architectural styles. The brick house at the corner has served as a funeral home since the beginning of the 20th century. From 1897 to 1936, it was owned by Charles Goshen, and then it was owned by Reuben Hartzell from 1936 to 1960. Presently, it is the Longnecker Funeral Home. (Bartholomew postcard.)

Five

NORTH WALES
RESIDENCES

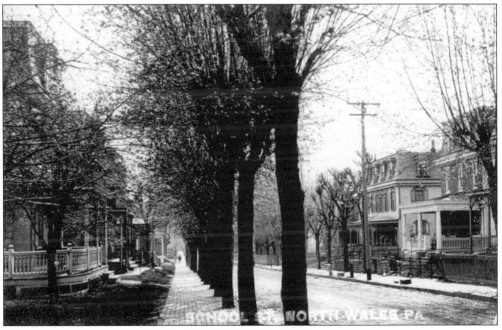

SCHOOL STREET. Victorian homes with stately mansard roofs and porches dominate the 400 Block of School Street in this view looking east toward the railroad station from Fourth Street. (Bartholomew postcard.)

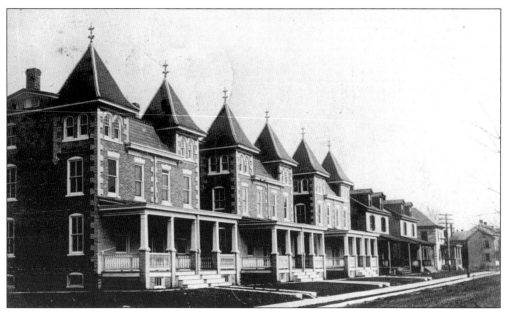

ON WALNUT STREET. By the time this postcard was made in 1909, North Wales was 40 years old. This view shows recently constructed homes on West Walnut Street. Fine architectural details characterize these stately twin, brick homes. This block, located on the north side of the street, remains similar to this view. (Bartholomew postcard.)

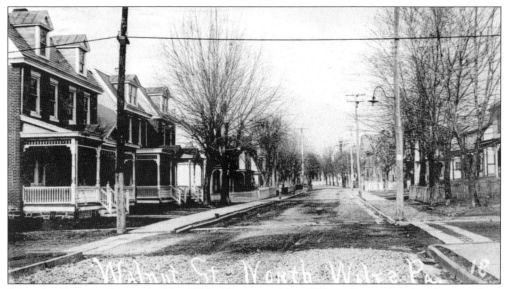

WALNUT STREET. Postmarked in 1906, this postcard is a Walnut Street view looking east from Pennsylvania Avenue toward Main Street. All of the homes on the left side of the street are still standing, as are most on the right side. Notice the dirt surface of the street. (Bartholomew postcard.)

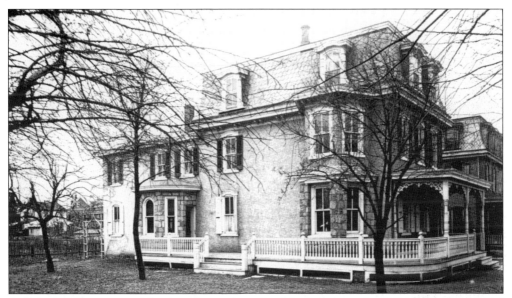

A PRIVATE RESIDENCE. The founding and much of the early growth of North Wales occurred in the Victorian era and is represented well in much of the town's architecture. This house, still standing on Fourth and School Streets, contains many Victorian features, including fancy wood trim, a wraparound porch, and a mansard roof. (Miller postcard.)

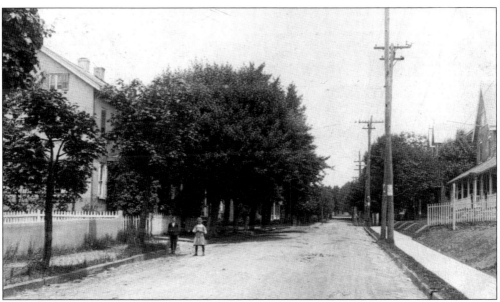

SCHOOL STREET FROM MAIN STREET, 1909. Two children play on an empty School Street in this view, which looks east. School Street connects Main Street with the railroad station, and contains some of the borough's oldest homes, many dating from the mid-1800s. All of the homes shown here are still standing. (Sliker postcard.)

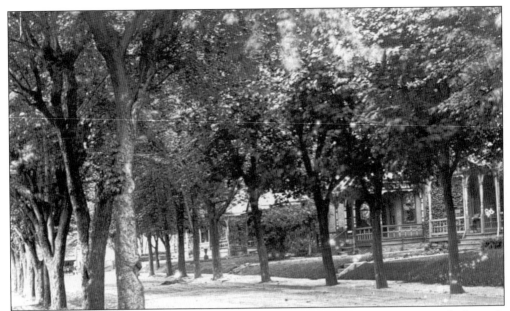

EAST MONTGOMERY AVENUE. A very shaded Montgomery Avenue near Fourth Street is shown in this 1910 view. The homes, with their porches, still stand, but the shade trees are gone. As with many streets in the borough, new curbs and sidewalks have been installed over the years, and many curb trees have been removed. (Miller postcard.)

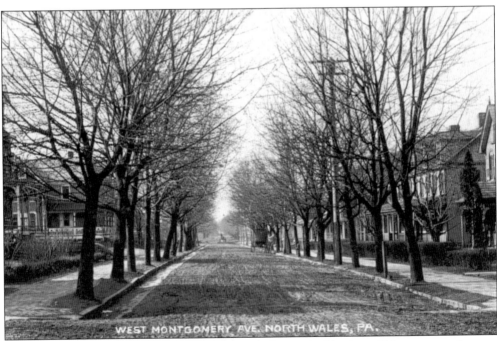

WEST MONTGOMERY AVENUE, 1910. Most of the homes in this view of Montgomery Avenue, looking west from Swartley Street, are still standing. (Miller postcard.)

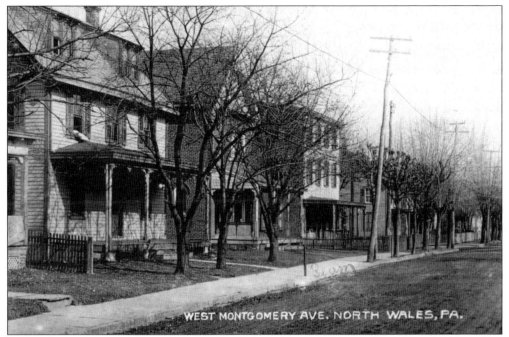

WEST MONTGOMERY AVENUE, 1910. This is the north side of Montgomery Avenue, looking east from Swartley Street to Pennsylvania Avenue. These homes still stand. (Miller postcard.)

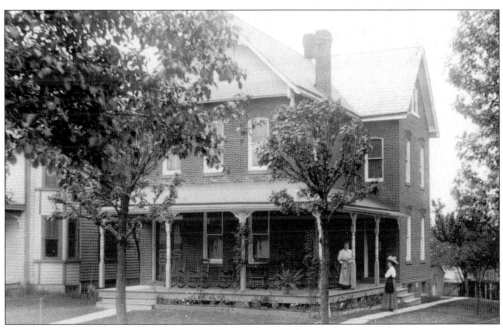

A PRIVATE RESIDENCE, 1910. This private residence on Montgomery Avenue near Pennsylvania Avenue has remained unchanged. (Sliker postcard.)

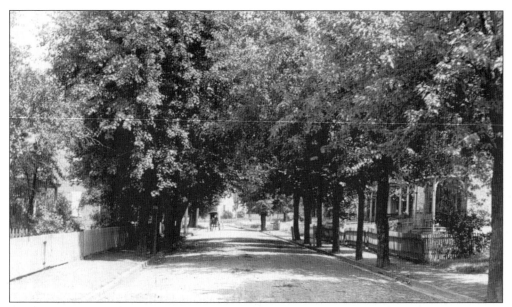

FIFTH STREET, 1907. From its founding in 1869, North Wales has always contained tree-lined residential streets. This view shows a very peaceful Fifth Street near Montgomery Avenue. Although new homes have been built in this block, many century-old buildings still remain. (Sliker postcard.)

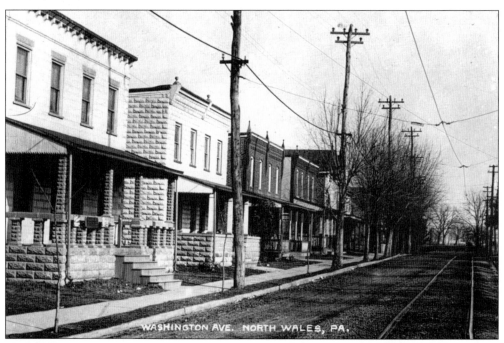

WASHINGTON AVE. NORTH WALES, PA.

WASHINGTON AVENUE. This view shows a residential area of North Wales on Washington Avenue looking east from Pennsylvania Avenue. Newly constructed twin homes line the north side of the street, some containing attractive cut stone blocks. These homes still stand, though many of the stone exteriors have been covered up with plaster. Note the trolley tracks heading towards Main Street. (Miller postcard.)

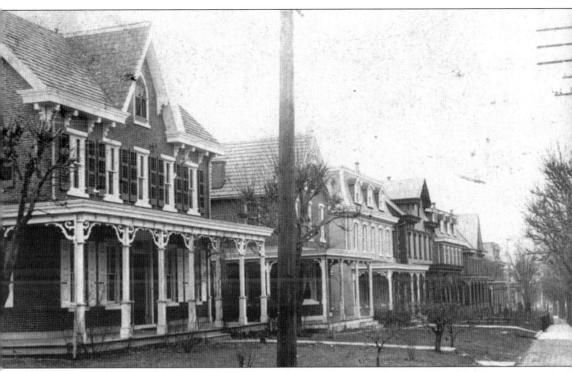

MAIN STREET, NORTH WALES, 1908. Stately Victorian homes line the west side of Main Street north of Shearer Street. Each home is unique, and most were built between 1850 and 1900. These homes still stand, but most do not have their porches. (Bartholomew postcard.)

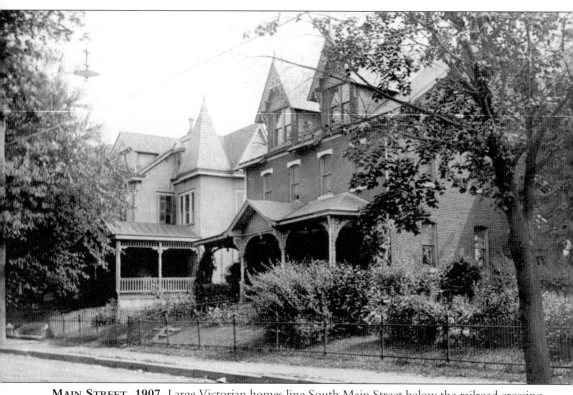

MAIN STREET, 1907. Large Victorian homes line South Main Street below the railroad crossing. The area south of the business district contained many high-styled residences on Main Street, of which most have been preserved, including the homes in this view. (Bartholomew postcard.)

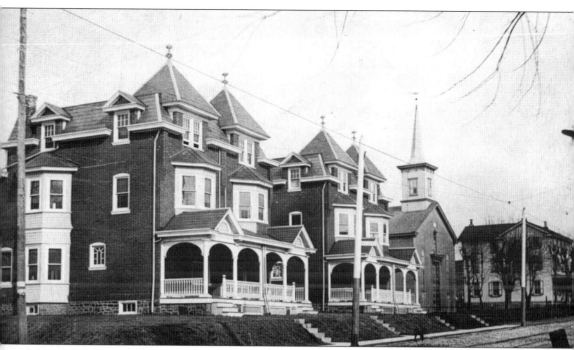

ON MAIN STREET. This 1905 view shows the east side of North Main Street, looking south from Elm Street. All of the buildings shown here are still standing, with the exception of the church. St. Luke's United Church building, shown here, was built in 1866, torn down in 1908, and replaced by the present church. (Bartholomew postcard.)

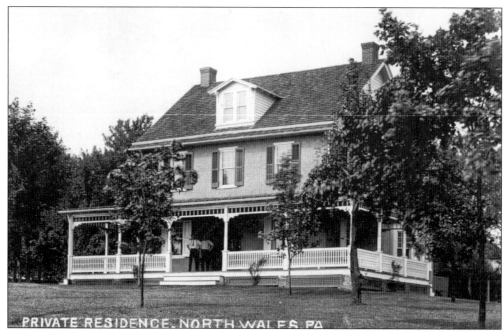

PRIVATE RESIDENCE. NORTH WALES PA

A PRIVATE RESIDENCE. Typical of country houses in the North Wales area is the house in this view, described as a private residence. Characterized by large porches and manicured lawns, homes like these reflect solid middle-class life in the area. This home is still standing with its small barn and is located on Main Street above Royal Avenue, but the porch is gone. (Miller postcard.)

MAIN STREET, NORTH WALES. With over 100 years of growth and progress, it is likely that some buildings vanished, almost with notice. Such is the case with these two brick homes on Main Street in North Wales. (Bartholomew postcard.)

Six

NORTH WALES SCHOOLS, CHURCHES, AND CREEKS

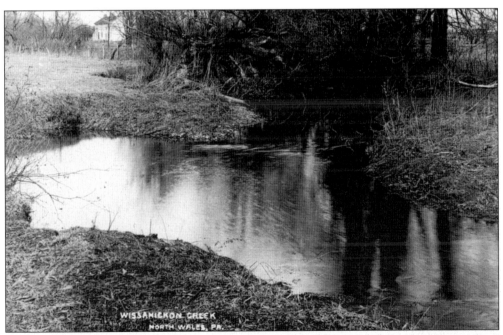

THE WISSAHICKON CREEK. Branches of the Wissahickon Creek pass by to the north and south of North Wales before joining to form one stream near Swedesford and Township Line Roads in Upper Gwynedd Township. This 1920 view shows one of the smaller branches of the creek near North Wales. (Miller postcard.)

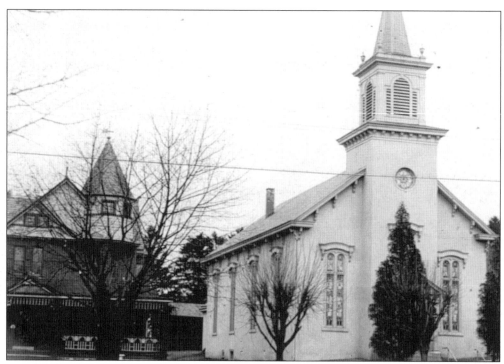

THE LUTHERAN CHURCH, 1910. Lutherans settled in the area of what is presently North Wales in the late 1700s. In 1868, the cornerstone of St. Peter's Lutheran Church was installed. Located on South Main Street at Church Street, the church has expanded to include other buildings. (Bartholomew postcard.)

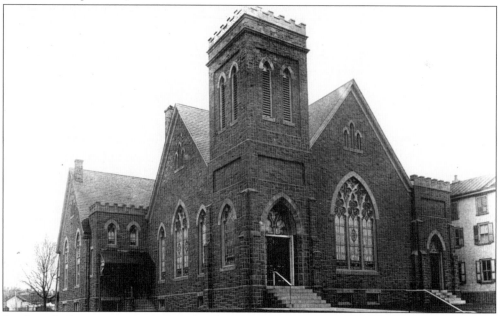

ST. LUKE'S REFORMED CHURCH. This church has long been a landmark on North Main Street. St. Luke's beginnings predate the founding of the borough. An original church was built in 1866, which was replaced by this building in 1909. (Miller postcard.)

SHEARER STREET. This 1910 view is looking east on Shearer Street from the corner of Pennsylvania Avenue. On the left is the North Wales Baptist Church. Founded in the mid-1800s as the Gwynedd Baptist Church and originally located on Allentown Road near Sumneytown Pike, this building dates from 1874. Note the trolley in the distance. (Bartholomew postcard.)

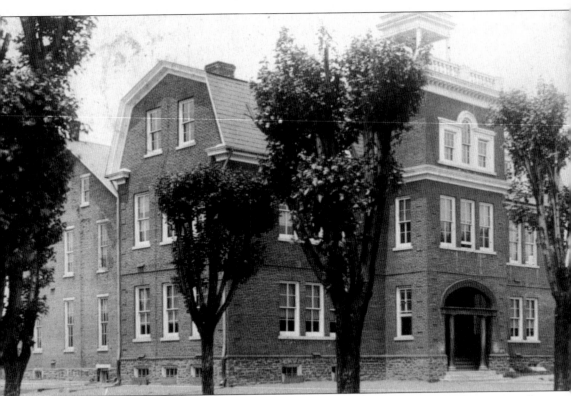

THE PUBLIC SCHOOL, 1910. Public schools in North Wales trace their beginnings to the founding of the borough in 1869. Various early schools had different locations on Main Street, until 1877, when a school was built on School Street. In the 1890s, this school was enlarged and remained the borough's only school, containing all 12 grades. In 1928, a larger school on Summit Street was built. In 1960, this school was extensively remodeled and its upper floors were demolished. The building presently serves as borough hall. (Sliker postcard.)

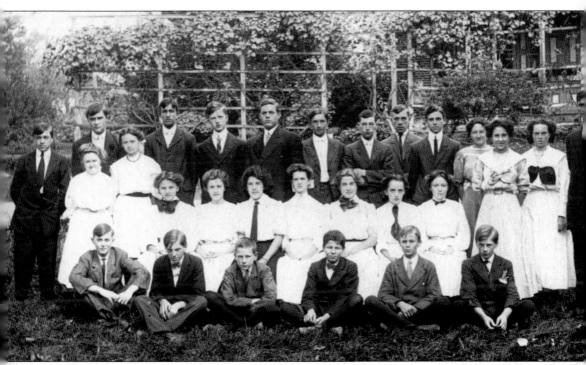

THE JUNIORS AND SENIORS OF NORTH WALES HIGH SCHOOL. This view captures the junior and senior classes at North Wales High School. Only 15 boys and 12 girls pose for this William Sliker postcard, postmarked 1908. Schools in rural Montgomery County had small student populations, and the number that attended high school was even smaller. The professor, B.A. Kline, is on the right, and the students are dressed in formal school attire. A flowering arbor forms the background for this photograph.

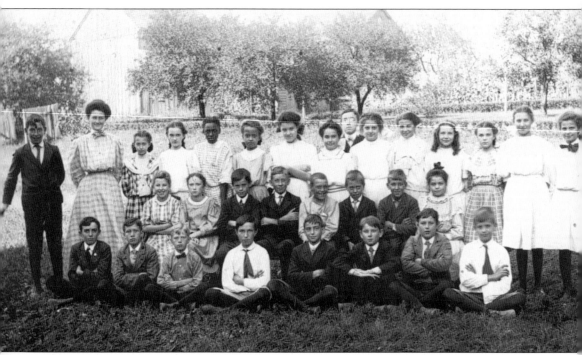

GRADE SIX OF NORTH WALES PUBLIC SCHOOL. The sixth-grade class of Grace Hubbard is shown *c*. 1908 at the North Wales Public School. Girls in attractive white dresses contrast with the dark suits worn by the young boys, who have appeared to have been instructed to fold their arms for this portrait. The photographer, William Sliker, captured many class pictures for postcards. In his later years, Sliker photographed many school class portraits in his native Northeast Philadelphia.

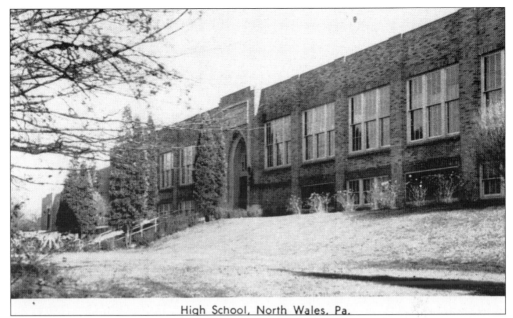

High School, North Wales, Pa.

THE HIGH SCHOOL. The North Wales High School was built in 1927 on Summit Street between Second and Fourth Streets. When first built, it was designed to contain grades 7 through 12. In 1951, a large addition was built onto the school. Years later, with the creation of the North Penn School District, high school classes were moved to Lansdale, and this building became known as North Wales Elementary School. The North Wales Library also occupies this building. (Seeman postcard, 1950.)

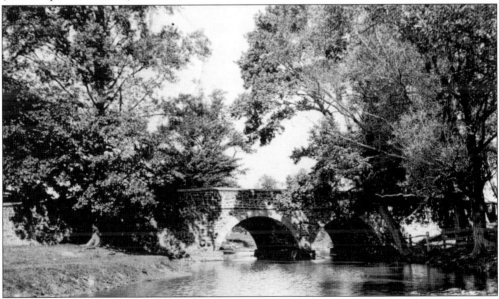

THE WISSAHICKON CREEK, 1905. This view shows the old stone, twin arch bridge that carried Walnut Street (North Wales Road) over the Wissahickon Creek, west of the borough. This bridge is typical of those built in Montgomery County in the 1800s and 1900s. They were usually constructed of local stone. This span has been replaced by a modern concrete bridge. (Bartholomew postcard.)

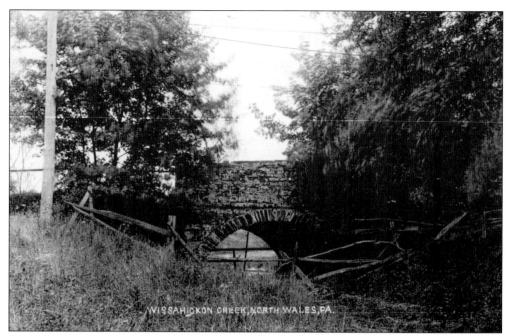

THE WISSAHICKON CREEK. The Wissahickon Creek is accentuated by an old, rustic, stone arch bridge in this view. Near the bottom of the bridge are old wooden fences spanning the creek. These were often put into place to keep cattle from roaming away from farm pastures. Scenic images like this are seldom seen today, as most small rural bridges that once carried horse and carriages have been replaced to handle heavy automobile traffic. (Miller postcard.)

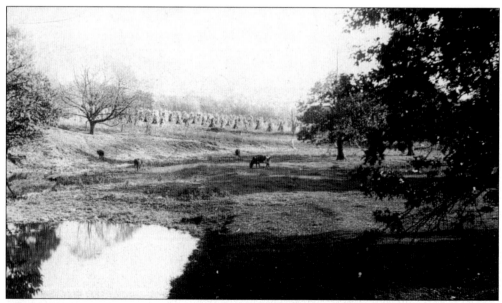

THE WISSAHICKON CREEK. This is a peaceful, pastoral view of the Wissahickon Creek south of North Wales at Sumneytown Pike from 1907. Farm animals roam freely in the wide open spaces that dominated the rural landscape of the North Penn area. (Sliker postcard.)

Seven

OUTLYING NORTH WALES AND GWYNEDD

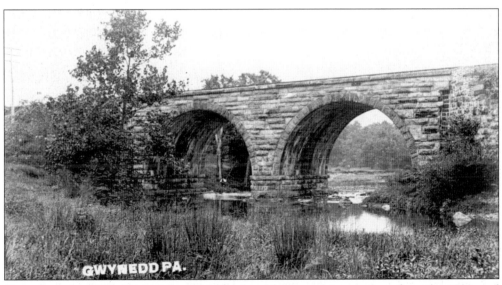

GWYNEDD, C. 1905. One of the original railroad bridges, this span dates from the 1800s and carried the North Penn Railroad over the Wissahickon Creek. (Bartholomew postcard.)

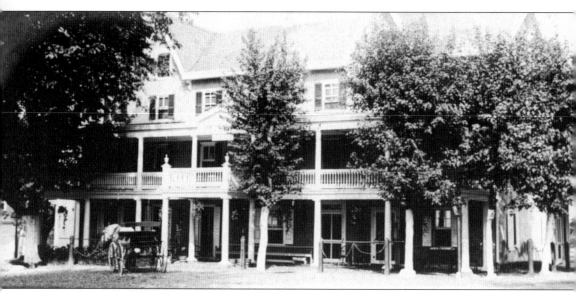

THE WILLIAM PENN INN, GWYNEDD, 1910. One of the most locally famous and oldest restaurants in suburban Philadelphia is the William Penn Inn. Situated at the intersection of Dekalb Pike (formerly State Road) and Sunmeytown Pike, the inn dates from the very early 1700s and was named after the beloved founder of Pennsylvania. Gwynedd was an early and important settlement of Welsh Quakers, and their meetinghouse still stands across the road from the old inn. (Bartholomew postcard.)

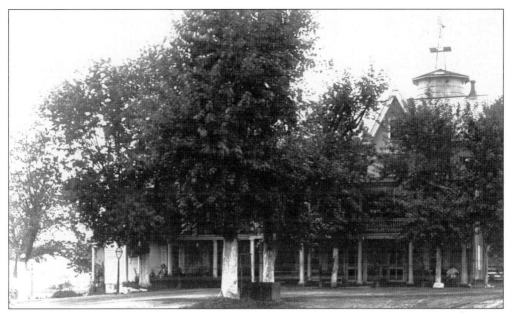

THE WILLIAM PENN INN. A very rural looking William Penn Inn, almost completely hidden by trees, is shown in this 1915 scene along DeKalb Pike. Prior to the advent of street lights, many tree trunks were whitewashed to help them stand out to travelers at night. (Miller postcard.)

THE FRIENDS MEETINGHOUSE, GWYNEDD, 1910. The early Quaker influence in the North Penn area was mainly centered in the vicinity below North Wales. The Gwynedd Friends Quaker Meetinghouse is one of this region's best known. Dating from the settlement of the Welsh Quakers in the late 1600s, the meetinghouse still stands and recently had a large addition built. It remains a very active place of worship. (Miller postcard.)

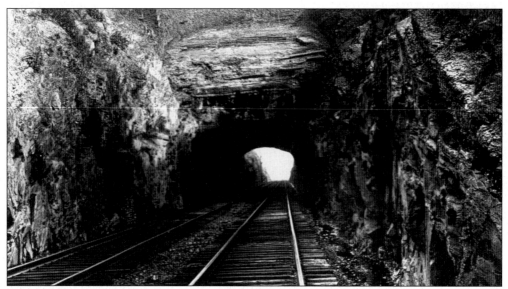

THE GWYNEDD TUNNEL. In the 1850s, when the North Pennsylvania Railroad began to clear ground for its line, they encountered solid rock in the area north of Dekalb Pike in Upper Gwynedd Township. Due to the rocky terrain, they were forced to do a great deal of digging and blasting, which resulted in the formation of the Gwynedd Tunnel. As time passed, the tunnel was eventually removed, however, commuters on the R–5 SEPTA line can still view the rock-like canyon in the vicinity of the Swedesford Road overpass. (Miller postcard.)

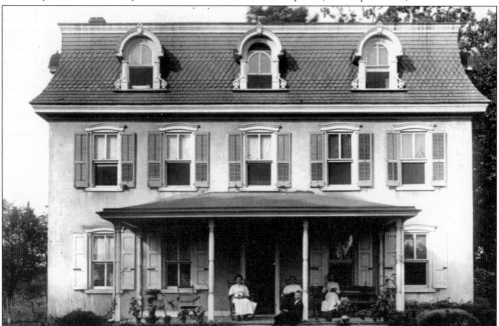

THE WISSAHICKON FARM, NORTH WALES. The area in and around North Wales contains many homes built in the mid-1800s. Three-story, mansard roof homes seemed to be the preferred style of that period. Many homes look like the Wissahickon Farm, but the author has been unable to locate this property. Needless to say, the view shows a country property with the family enjoying a gathering on the porch. (Miller postcard.)

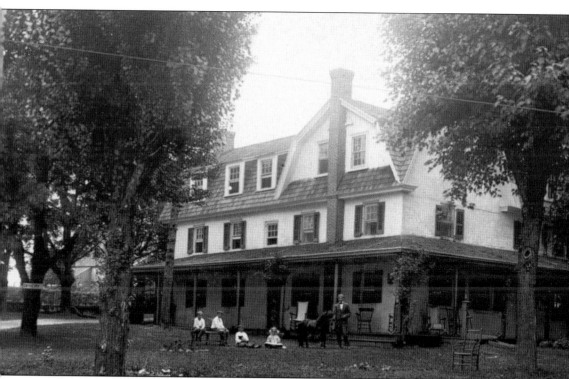

GWYNCROFT, NORTH WALES. Travelers driving along Sumneytown Pike from Route 202 into North Wales will pass a large colonial house with a pointed stone facade and hip roof on a small hill above the Wissahickon Creek. This home is Gwyncroft, one of the oldest and most historic homes in the area. An original land grant from William Penn deeded 250 acres to a Welsh Quaker, Thomas Evans, in 1699. Soon afterward, Evans erected a log cabin. This cabin was incorporated into the present house. Legend, as well as historic documentation, states that William Penn visited the Gwynedd area, where Welsh Friends were some of the first settlers to arrive. Accounts of Penn's visit states that he stayed at Evan's log house and was witnessed praying and giving thanks for the land of Pennsylvania. The Evan's family owned the property until 1806, when Philip Heist purchased the farm. Today, the property includes a stone barn set among mature trees. (Sliker postcard.)

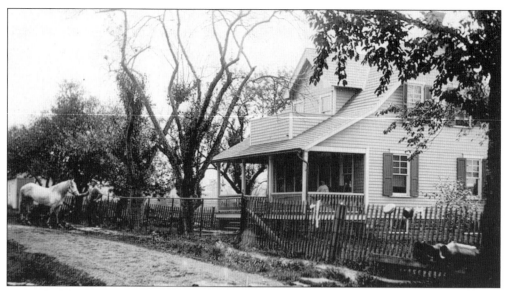

NEAR NORTH WALES. This rural scene shows the tenant's or caretaker's house for the Gwyncroft Farm. Tenant homes were places where farm workers would live. The scene, complete with a man and a horse, is a good representation of the country atmosphere around North Wales. This home, built in 1867, is still standing on Upper Valley Road and has been remodeled. (Bartholomew postcard.)

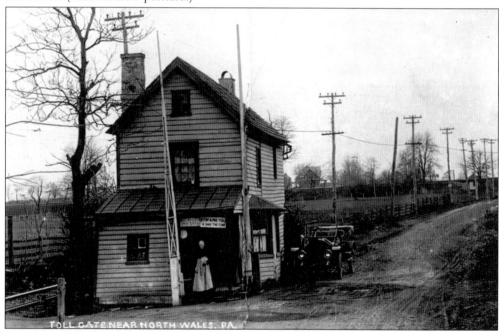

THE TOLL GATE, NORTH WALES. From the 1800s to the early 1900s, many old roads operated as turnpikes, using the toll system for collecting revenue. Sumneytown Pike was one of those early turnpikes. This scene, looking west, shows the old toll gate at the corner of Sumneytown and West Point Pikes. The toll collector is Margaret Rhoads, who tended this spot from 1855 to 1911. In the early 1900s, this type of turnpike and tollgate became obsolete. The Sumneytown Turnpike system ended in 1914. (Miller postcard.)

Eight

MONTGOMERYVILLE AND COLMAR

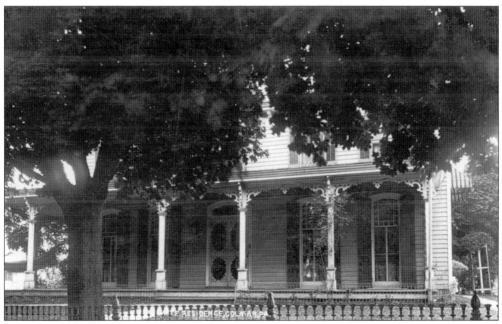

A PRIVATE RESIDENCE, COLMAR. Almost obscured by a shady maple tree is a private home with a porch. Note the delicate wood trim and large Victorian-style windows and doors. (Miller postcard.)

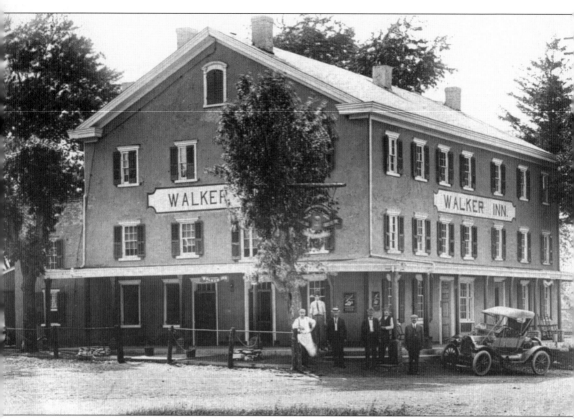

THE WALKER INN, MONTGOMERYVILLE, 1917. After the incorporation of the Spring House and Hilltown Turnpike (Bethlehem Pike) in 1813, the village of Montgomeryville grew steadily. The junction of other important highways, such as the Doylestown Road and Horsham Road, made Montgomeryville an important village. The village consisted of a number of buildings, including a general store and school, but the most prominent was the Montgomeryville Hotel, built in 1814. Said to be the largest hotel between Philadelphia and Bethlehem, the hotel was a vital center to the village and surrounding township. Philip Walker purchased the hotel in 1917 and renamed it the Walker Inn. Situated on the southwest corner of the five points intersection, the hotel was torn down in 1949 to widen the increasingly busy Bethlehem Pike. Shown in this view are local Montgomery Township residents with an antique car. (Miller Postcard.)

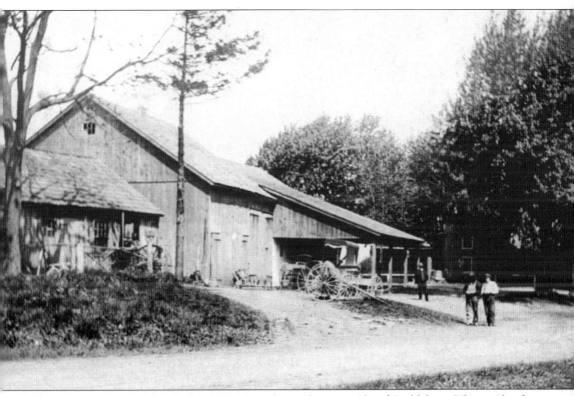

MONTGOMERYVILLE, 1910. This 1910 view shows the west side of Bethlehem Pike south of Horsham Road. This barn-like building, containing a variety of carriages, was the village blacksmith and carriage shop, an important trade of that time. Notice the empty dirt road that was Bethlehem Pike. On the extreme right of this view is the south side of the Walker Inn. (Bartholomew postcard.)

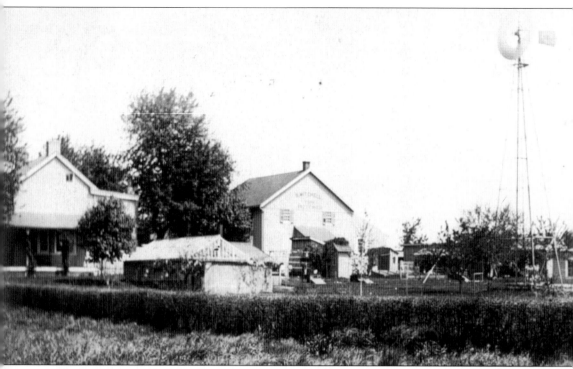

MONTGOMERYVILLE. This 1910 view shows rural farm life in Montgomery Township. Faintly seen on the right building is "S. Mitchell—Pork Butcher." Samuel Mitchell was a pork butcher on his farm, once located on the north side of Doylestown Road (Route 202), north of the Montgomeryville intersection. (Bartholomew postcard.)

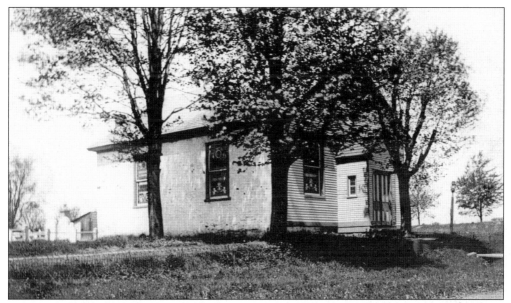

The Methodist Episcopal Church, Montgomery Square. At the junction of Bethlehem Pike and Upper State Road was the village of Montgomery Square. It was the oldest village in Montgomery Township, dating from the early 1700s. The Methodist Episcopal church, located on Bethlehem Pike south of Route 202, was founded in 1842. Its cemetery dates from 1879. This building, with additions, is still standing, and the church is quite active in the community. (Bartholomew postcard.)

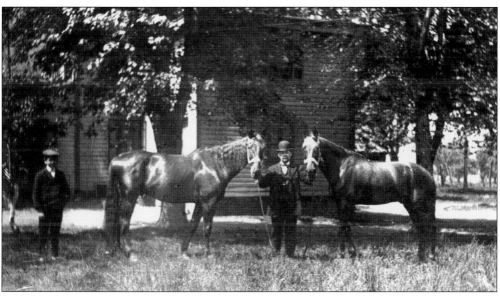

Montgomeryville, 1915. Walter Carrell Service is shown in 1915 on his farm, which once stood on the south side of Stump Road west of County Line Road in Montgomery Township. Appropriately posed with two horses, he boarded horses on his farm in the early 1900s. Horses were very important for transportation and farming. The farm buildings were torn down in the 1990s.

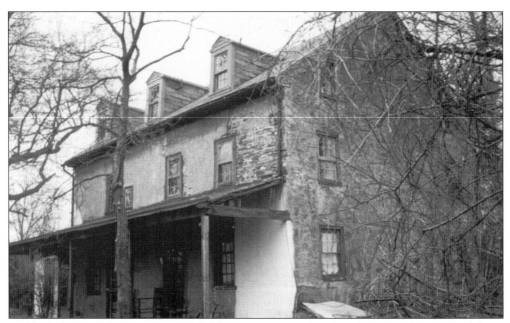

THE KNAPP FARM, MONTGOMERY TOWNSHIP. One of the North Penn's best-known farms is the Knapp Farm, located on DeKalb Pike at Knapp Road. It was until recently the township's last working farm. The herd of dairy cows existed until 1996. The exact date that the buildings were erected is not clear, though one legend contends that George Washington stayed at the farm in the 1770s while traveling from New Hope to Valley Forge. The Knapp family has owned the property since 1835.

A BARN AND FARM BUILDINGS, KNAPP FARM. The Knapp family was well known throughout the generations they lived on their farm. Longevity seems to characterize many members of the family. Mary Knapp lived to the age of 107, Florence Knapp lived to 105, C. Howard Knapp lived to 94. The farm, located next to the Montgomery Mall, was recently sold, and houses will eventually be built on this historic property. Fortunately, the farmhouse and some of the grounds will be saved. The farmhouse was placed on the National Register of Historic Places in 1976.

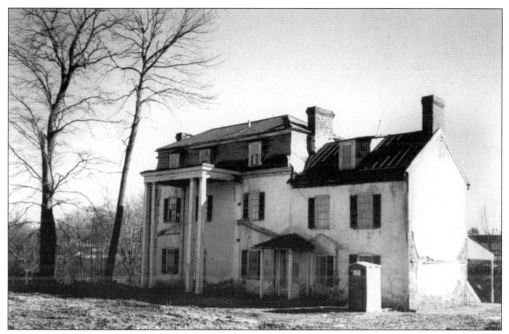

THE WITCHWOOD FARMHOUSE. This is the old farmhouse that was part of Witchwood, shown here prior to being restored. Today, this building and a springhouse are all that remain of this farm. In the 1800s, a wealthy Philadelphia builder, William Armstrong, owned the farm. His company built many prominent buildings in Philadelphia. The original farm dates from the 1700s. From 1936 to 1951, the farm was owned by Tasty Baking Company co-founder Philip Baur.

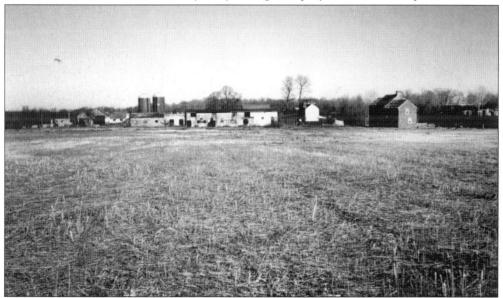

THE WITCHWOOD FARMS. This farm was formerly located on the west side of Bethlehem Pike north of Stump Road. Witchwood was a dairy farm that also operated a dairy or ice-cream bar in the mid-1900s. They produced their own brand of dairy products, including ice cream. This view shows the farm prior to being developed into the Montgomery Square Shopping Center. To the right are two old houses, and in the middle was the dairy operation.

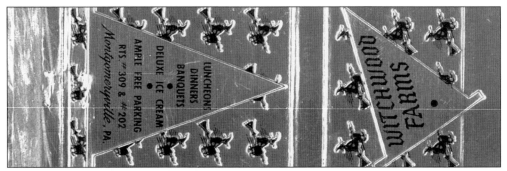

THE WITCHWOOD FARMS, MONTGOMERYVILLE. Witchwood Farms supposedly acquired its name from confusion surrounding a wooded area to be cleared and a farm worker asked "which woods?" This matchbook cover from the 1950s depicted the farm in a different manner, with witches riding broomsticks.

THE JOSEPH AMBLER INN. The Joseph Ambler Inn is one of North Penn's oldest buildings. The original stone house was built in 1734 by Joseph Ambler and stands on Horsham Road in Montgomery Township. The large stone barn dates from the 1820s and serves as a restaurant.

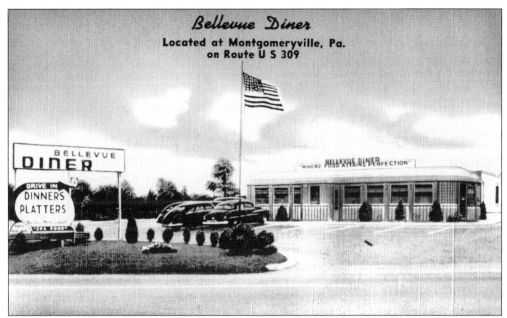

THE BELLEVUE DINER, MONTGOMERYVILLE. A likely choice for a diner location would be along Route 309 at the five points intersection, which is where the Bellevue Diner once stood. Built after World War II, it stood on Horsham Road at Bethlehem Pike. This linen-style diner postcard dates from 1950. In the late 1950s, this diner was closed, and the building was moved up Route 309 to Coopersburg.

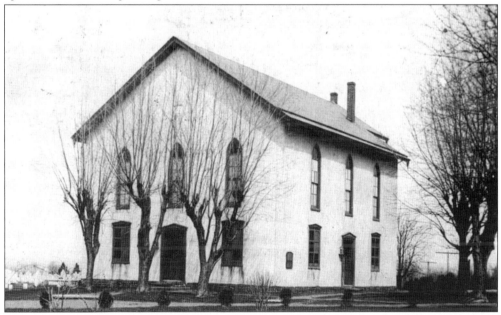

THE MONTGOMERY BAPTIST CHURCH, COLMAR. A mile north of Montgomeryville on Bethlehem Pike is the village of Colmar. Midway between the two villages stands the Montgomery Baptist Church, which dates from 1719. The adjacent cemetery also dates from that year. A log church was built in the 1720s and replaced by a stone building in 1731. This building, still standing, was remodeled in the 1880s from an 1816 structure. (Bartholomew postcard.)

97

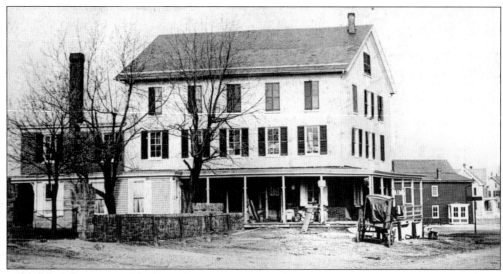

COLMAR, 1910. This large, three-story building was built in 1878 on Bethlehem Pike at the railroad crossing. Colmar village developed when the railroad built a station at Bethlehem Pike north of Broad Street in 1875. This building served as the village general store and post office. The store is no longer in existence, but the post office continues to operate in this building. (Bartholomew postcard.)

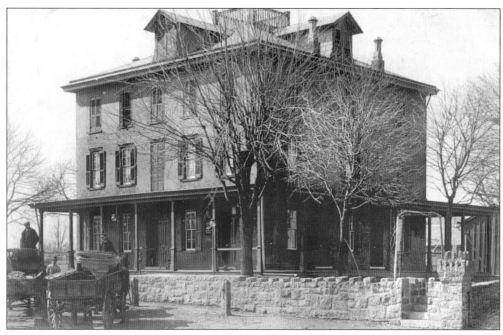

A HOTEL IN COLMAR, 1915. Dating from the mid-1800s, the Colmar Hotel is located on the west side of Bethlehem Pike next to the post office, north of Broad Street. Note the old horse-drawn wagons parked in front of the building. Today, the building operates as the Colmar Inn, and its appearance is similar to this view. (Miller postcard.)

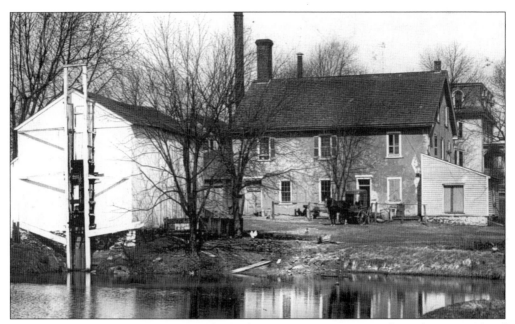

THE COLMAR CREAMERY, 1910. The Colmar Creamery once stood on the west side of Bethlehem Pike north of Line Street. This establishment was in business from the late 1800s to the mid-1900s. The cool spring-fed pond near the Neshaminy Creek was ideal for aiding in refrigeration of dairy products. (Miller postcard.)

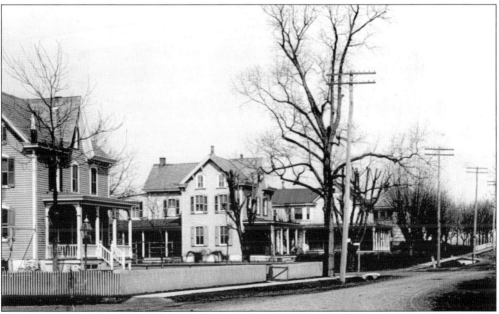

MAIN STREET, COLMAR, 1912. This view shows Colmar's Main Street, the Bethlehem Pike, looking north toward the intersection of Walnut Street. The two buildings on the left are still standing, though somewhat remodeled into businesses. Notice how wide the pike is in this early-1900s view. (Miller postcard.)

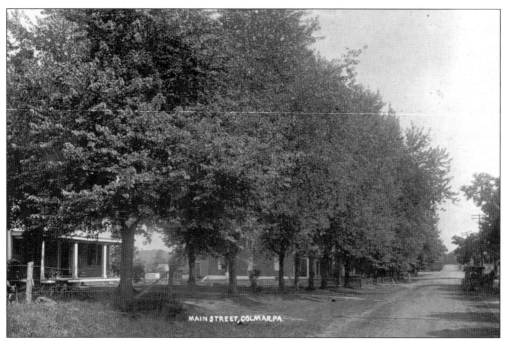

MAIN STREET, COLMAR, 1914. This is another early view of a wide and empty Bethlehem Pike in Colmar. Large shade trees no longer line this road. (Miller postcard.)

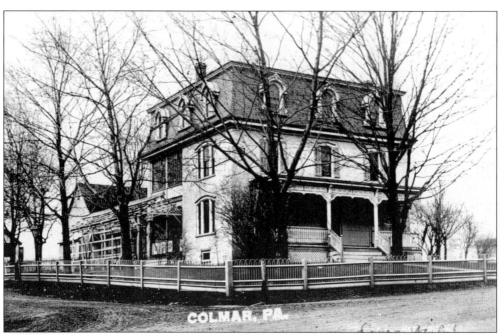

COLMAR, 1910. This 1910 postcard illustrates the high style of architecture that represented modest wealth in the late 1800s in Colmar. This large home, built in the 1880s, has three floors, a mansard roof, elegant wood trim, and a spacious porch facing Bethlehem Pike. This house in the 1890s belonged to the Sellers family and was north of the creamery. It is no longer standing. (Bartholomew postcard.)

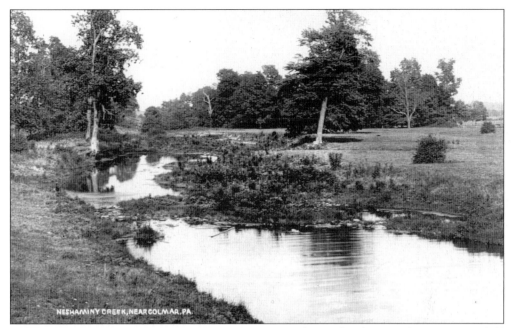

THE NESHAMINY CREEK, NEAR COLMAR, 1917. Several natural underground springs in Hatfield Township are the source for a branch of the meandering Neshaminy Creek. This view shows the Neshaminy near Colmar, with plenty of wide open meadows and pastures. (Miller postcard.)

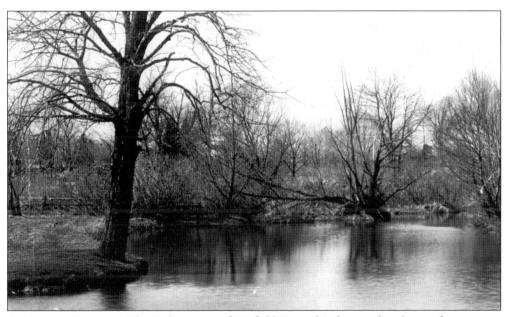

A LAKE IN COLMAR. The Colmar area of Hatfield Township has an abundance of waterways, natural lakes, and ponds feeding into the West Branch of the Neshaminy Creek. This *c.* 1910 scene shows a winter view of a small lake near Colmar. (Miller postcard.)

101

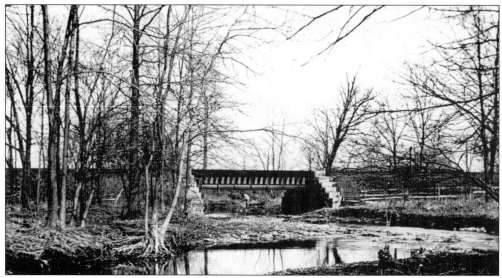

A RAILROAD BRIDGE. An old railroad bridge is shown in this 1915 view. The bridge spans the West Branch of the Neshaminy Creek near Colmar. (Bartholomew postcard.)

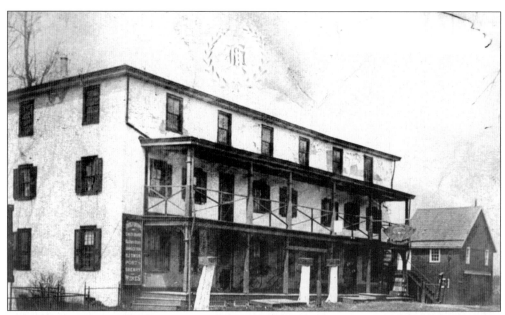

THE TREWIGTOWN HOTEL, COLMAR. Not more than a mile north of Colmar was the small crossroads village of Trewigtown. The village appears to have always remained small and rather insignificant, yet it is much older than the more prosperous towns of Colmar and Montgomeryville. This old hotel, which stood on the northwest corner of Bethlehem Pike and Trewigtown Road, dates from the mid-1700s. Jacob Trewig was the tavern keeper in the 1830s and 1840s. This building, along with most of the forgotten town, no longer exists. (Bartholomew postcard.)

Nine
HATFIELD BOROUGH AND TOWNSHIP

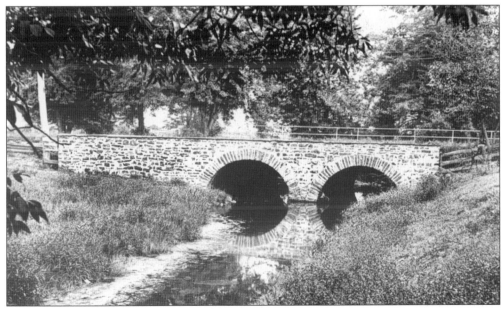

A HATFIELD BRIDGE. A stone, twin-arch bridge with its reflections in the creek provide an ideal picture for this postcard, which was mailed in 1913. Photographer John Bartholomew's artistic abilities make many of his views quite inviting and interesting.

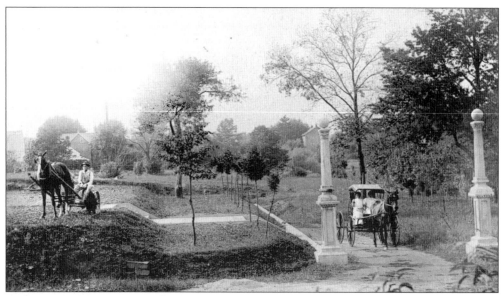

SOUTH HATFIELD, 1910. Hatfield Township was founded in 1742, and there appears to be no clear reason why that name was chosen. Welsh Baptists and German Mennonites were the first to inhabit the area. This unusual scene depicts several activities. To the left, a farmer seems to be riding a horse-drawn plow. To the right, two young ladies are out for a ride, driving between two decorative pillars. The newly planted trees in the middle, along with new concrete steps, seem to reflect that a residence had recently been built. (Bartholomew postcard.)

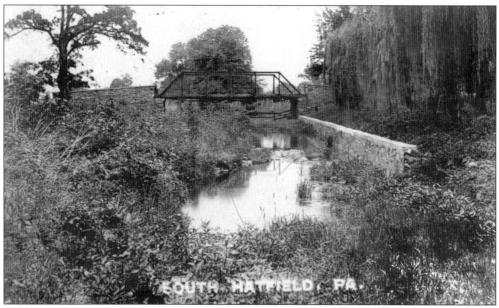

SOUTH HATFIELD, 1908. Hatfield developed in the 1800s, and two rather distinct communities were established. Upper Hatfield was centered around the North Pennsylvania Railroad Station, while South Hatfield was located at Cowpath Road and the railroad. This view shows an old steel bridge near South Hatfield. (Bartholomew postcard.)

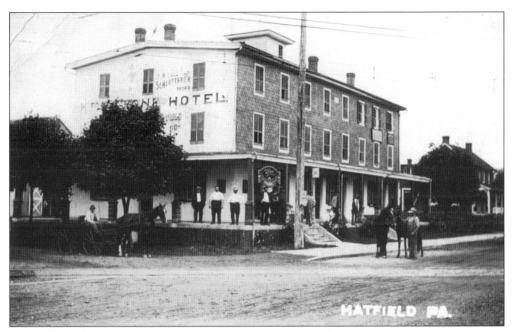

HATFIELD. Hatfield Borough was incorporated in 1898. Much of its early growth centered around the North Penn Railroad line and an early trolley route that operated in the borough. Pictured here is the Hatfield Hotel, known as the Keystone Hotel when this view was made. Strategically located on Main Street opposite the railroad, the hotel dates from 1867, when Hatfield was just a railroad village. Today, it is the Main Street Hotel. (Bartholomew postcard.)

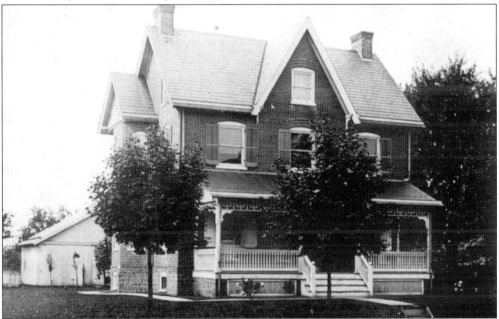

SOUTH HATFIELD, 1906. Much of the borough's early development occurred in the late 1800s. Most dwellings of this period were attractive, single, brick homes with decorative porches. This home, still standing on Vine Street in Hatfield Township, is a typical brick residence. (Bartholomew postcard.)

105

HATFIELD. This *c.* 1907 view shows the east side of Main Street north of Lincoln Avenue. The large home with the wraparound porch was built in 1905 by Levi Kratz. The retired farmer built this large house near the center of the borough. The house is no longer standing. (Bartholomew postcard.)

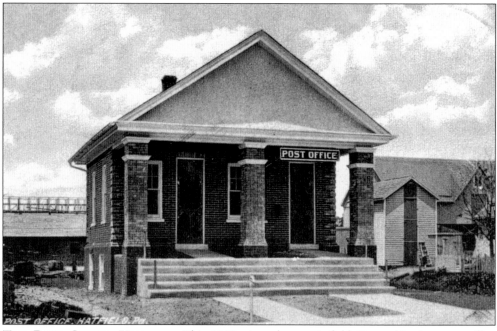

THE POST OFFICE, HATFIELD. This 1910 view shows Hatfield Borough's tiny post office building. The quaint brick building is adorned with brick columns and resembles a small Greek temple. This building still stands on East Broad Street, but is no longer the post office. This postcard was published by Isaac Detwiler, who operated a general store at Broad and Market Streets.

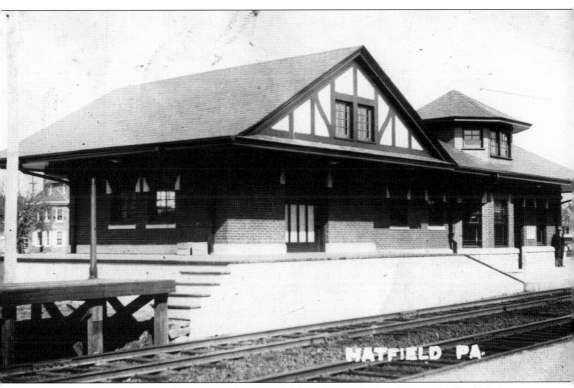

THE RAILROAD STATION, HATFIELD. The Hatfield Railroad Station is located off of Market Street opposite Broad Street along the old North Penn Railroad line. An original station was built in the 1870s, and a later addition was built in 1913. This station was erected in 1914. Trains no longer stop here, and this building has been a stove and art shop since the 1980s. (Bartholomew postcard.)

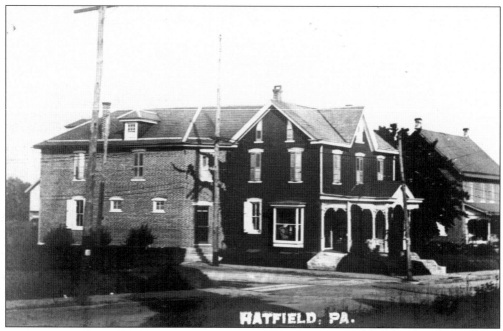

HATFIELD. Harry Frankenfield's general store is shown at the corner of Lincoln Avenue and Main Street in the borough. The building is currently occupied by a doctor's office. (Bartholomew postcard.)

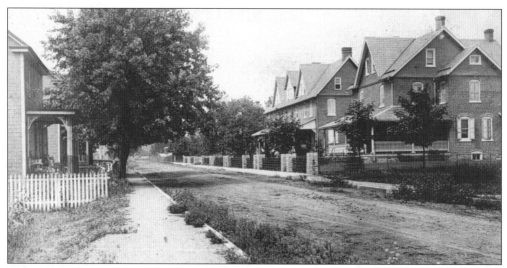

HATFIELD, 1908. This is a Maple Avenue view looking north towards Roosevelt Avenue near the railroad in Hatfield Borough. These homes still stand, but the wrought-iron gates and stone posts are gone. (Bartholomew postcard.)

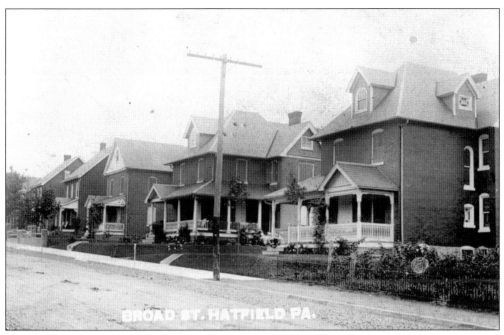

BROAD STREET, HATFIELD, 1910. This is a view of East Broad Street looking west toward Main Street in the borough. These solidly built brick homes still stand. (Bartholomew postcard.)

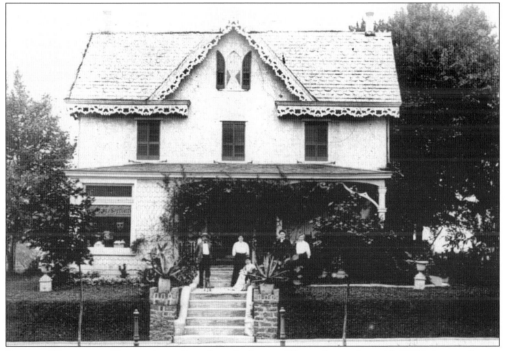

SOUTH HATFIELD. Decorative, gingerbread trim molding adorns the mid-1800s home shown here with a gathering of people *c.* 1906.

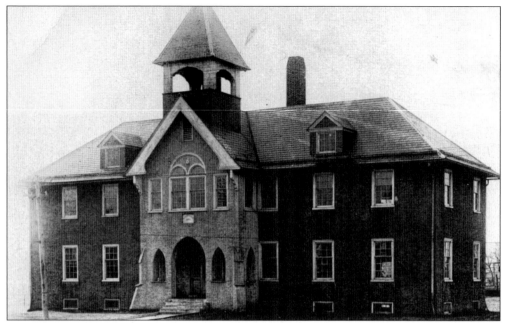

THE PUBLIC SCHOOL, HATFIELD. Located on Main Street above Lincoln Avenue, this school dates from 1885, when it contained only one classroom. Additions were added in the 1890s to create the appearance seen in this 1910 view. Though no longer a school, the building still stands. (Miller postcard.)

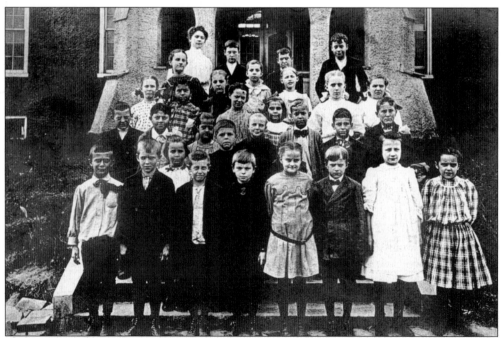

THE HATFIELD PUBLIC SCHOOL. This *c.* 1910 postcard captures students standing on the steps of the Hatfield Public School on Main Street in Hatfield Borough. The girls wear dresses and the boys wear suits and ties. The teacher appears in the upper left. Notice that not many pupils are smiling.

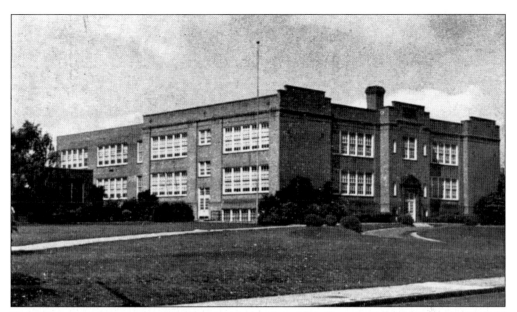

THE HATFIELD CONSOLIDATED SCHOOL. Located on Main Street at School Street, the Hatfield Consolidated School was built in 1922 and served all of Hatfield Township and Hatfield Borough. Unique for its time, it housed all 12 grades and contained a large auditorium and gymnasium. No longer a school, the building still stands and serves as a private religious institution.

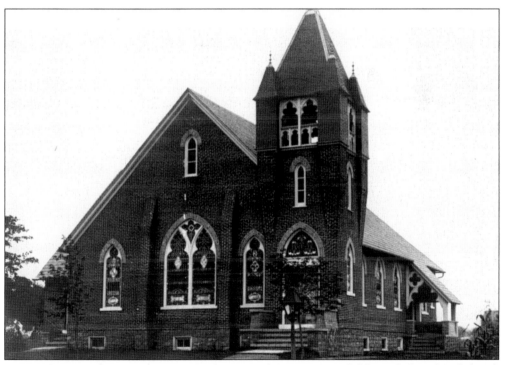

GRACE EVANGELICAL LUTHERAN CHURCH. Built in 1905, Hatfield's Lutheran church stands on Broad Street west of Main Street. This church was adorned with a handsome belfry, which has since been removed. (Bartholomew postcard.)

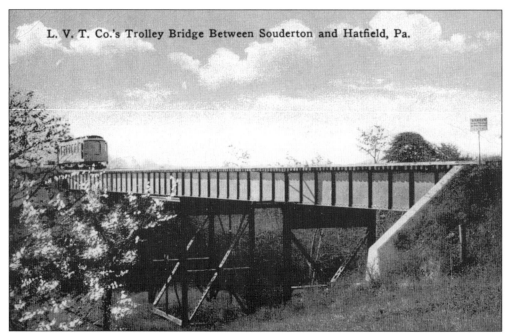

L. V. T. Co.'s Trolley Bridge Between Souderton and Hatfield, Pa.

THE LEHIGH VALLEY TRANSIT COMPANY'S TROLLEY BRIDGE. In 1899, the Inland Trolley Company began running trolleys from Lansdale to Perkasie. This line proved to be very successful and was extended from North Wales to north of Quakertown. The line was renamed the Lehigh Valley Transit Company. This view shows a trolley on a bridge north of Hatfield. Lansdale, Hatfield, and other towns had trolley stations built to serve the line. The trolley company shut down in 1951.

HATFIELD, 1910. The North Penn area was full of picturesque places, and local photographers captured many scenic views. Lynford Craven, a postcard publisher from Doylestown, locally famous for his scenes of Bucks County, crossed the county line and took this view of the West Branch of the Neshaminy Creek in Hatfield Township. Unspoiled images like this show how our area was.

HATFIELD. Life and times were much simpler in the early 1900s. This view shows a simple landscape with a pleasant grove of trees in the countryside near Hatfield. The exact location of this would be almost impossible to find today. (Bartholomew postcard.)

A CREEK VIEW, SOUTH HATFIELD. Pastoral scenery is in abundance along the West Branch of the Neshaminy Creek near South Hatfield. (Miller postcard.)

113

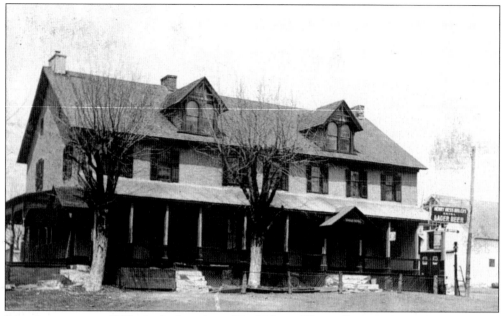

LINE LEXINGTON, 1908. At the junction of Bethlehem Pike, Hilltown Pike, and County Line Road is the village of Line Lexington. The village has the distinction of being in two counties (Bucks and Montgomery) and three townships (Hatfield, New Britain, and Hilltown). The Eagle Hotel, pictured here, was an early tavern dating from the 1700s. It is no longer standing. (Bartholomew postcard.)

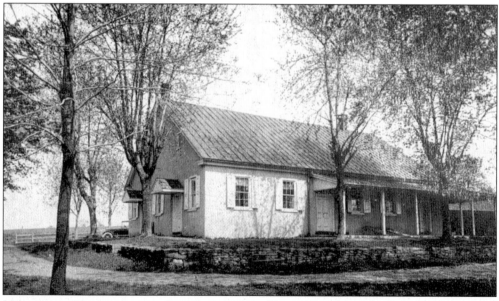

MENNONITE MEETINGHOUSE, LINE LEXINGTON. German immigrants in the early 1700s settled in central Montgomery and Bucks Counties. These deeply religious people, known as Mennonites, built meetinghouses similar to those erected by the Quakers. The meetinghouses are some of the oldest churches in the area. Several were built in the Hatfield and Lansdale vicinity. This meetinghouse was built in Line Lexington, just over the county line in Bucks County, in 1868, and replaced a 1750s structure.

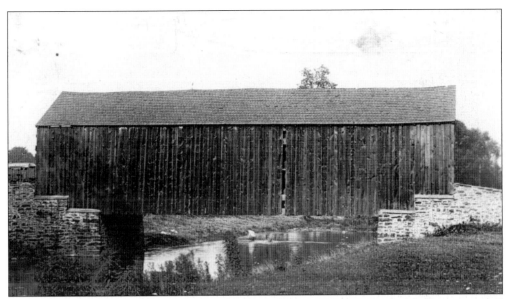

OLD BRIDGE NEAR LINE LEXINGTON, 1910. The North Penn area had at least two covered bridges in the Line Lexington area, both spanning branches of the Neshaminy Creek. One bridge was on Bethlehem Pike near Unionville, and the other was on County Line Road, south of Line Lexington. Both bridges were replaced by concrete structures in the 1930s. This postcard view appears to be of the County Line Bridge. (Miller postcard.)

LINE LEXINGTON. Views of endless farms are shown in the Line Lexington area *c.* 1910. This view, taken from a quarry on Hilltown Pike, shows the gently rolling farmland in Bucks and Montgomery Counties. (Bartholomew postcard.)

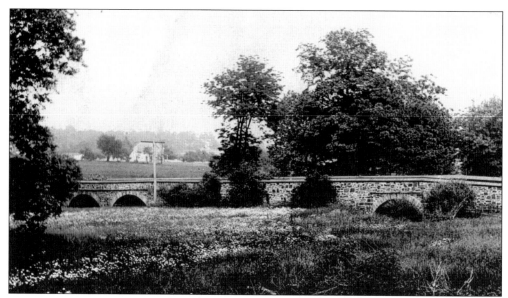

UNIONVILLE. The crossroads village of Unionville was at Bethlehem and Unionville Pikes in Hatfield Township. The village consisted of a few homes and a hotel on Bethlehem Pike. This old stone bridge spans a branch of the Neshaminy Creek. Montgomery County erected many bridges like this one in the 1800s and early 1900s. Many, like this span, have been replaced. (Bartholomew postcard.)

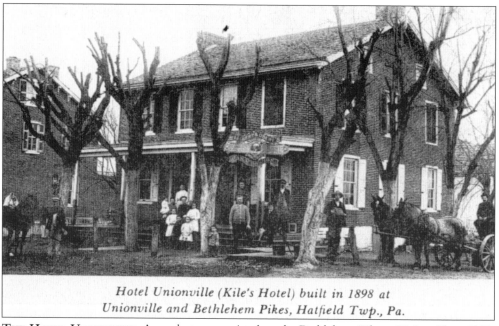

Hotel Unionville (Kile's Hotel) built in 1898 at
Unionville and Bethlehem Pikes, Hatfield Twp., Pa.

THE HOTEL UNIONVILLE. An early tavern existed on the Bethlehem Pike at Unionville *c.* 1800. That building burned down and was replaced by this hotel in 1898. This building is no longer standing.

Ten

KULPSVILLE AND WEST POINT

A STREET SCENE, KULPSVILLE. This is one of a series of eight hand-colored postcards of Kulpsville from the 1920s. This scene shows a variety of homes built during different periods on the south side of Sumneytown Pike looking west toward Forty Foot Road. Some of the homes in the distance have been demolished.

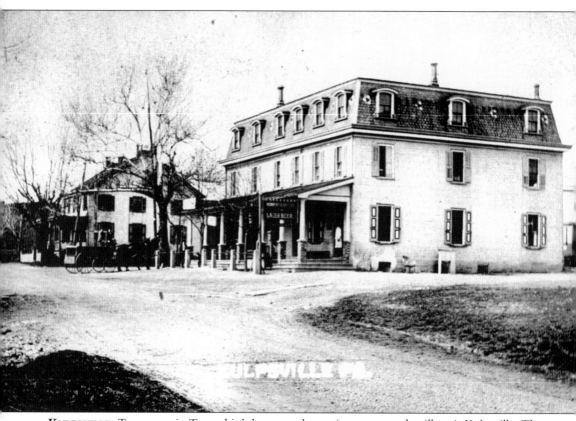

KULPSVILLE. Towamencin Township's largest and most important early village is Kulpsville. The village is named after Jacob Kulp, who, in 1776, owned 160 acres near Kulpsville along an important road, the Springhouse-Sumneytown Turnpike. Kulpsville's early importance as a village included having a library, a public hall, a voting place, and numerous buildings. This view looks west along Sumneytown Pike at Forty Foot Road to the Kulp and Stover General Store and S.C. Bean Hotel. (Bartholomew postcard.)

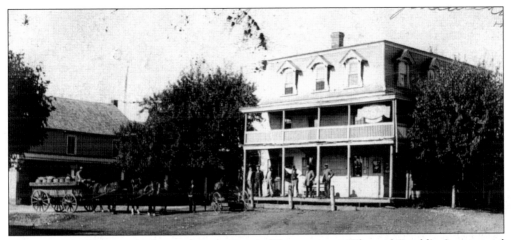

KULPSVILLE'S HOTEL. At the southwest corner of Sumneytown Pike and Franklin Street stood Kulpsville's hotel. Built in the late 1700s, the hotel had many owners and was known by many names. Prior to its demolition in the mid-1900s, it was known as Schuler's Hotel. This scene shows a lot of activity at the hotel, including the arrival of a horse-drawn delivery wagon. (Bartholomew postcard.)

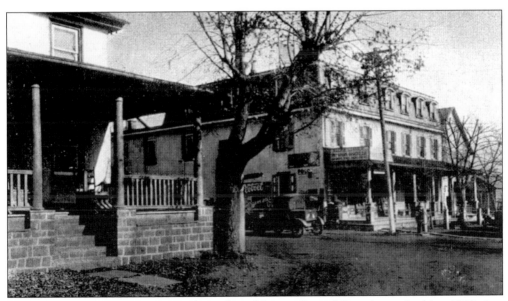

THE POST OFFICE, KULPSVILLE. The Kulp and Stover General Store is seen in this *c.* 1920 view looking east at the intersection of Sumneytown Pike and Forty Foot Road in Kulpsville. The building to the left and the store are no longer standing.

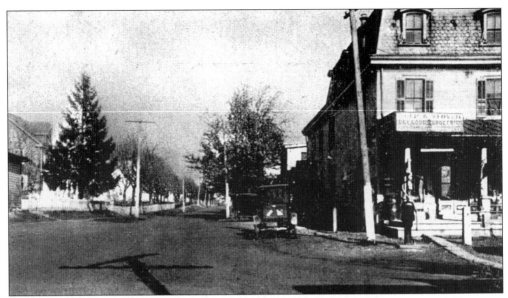

A Street View, Kulpsville. The photographer for this postcard must have stood in the middle of the intersection of Sumneytown Pike and Forty Foot Road to take this shot, something no one would dare attempt today. This 1920 scene is of Forty Foot Road looking north.

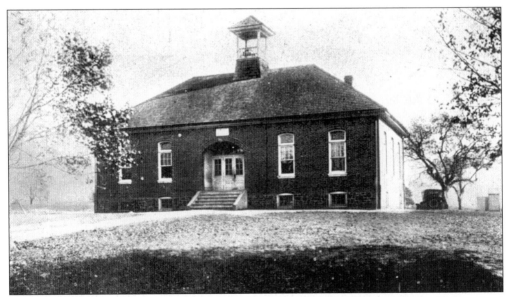

The Kulpsville School. The Kulpsville School was built in 1909 and originally contained two classrooms, as seen in this 1920 view. More classrooms were added in the late 1920s, 1936, and in 1957. This school was also known as Specht School, having been named after J. Henry Specht, a local educator and historian. This building, with additions, still stands on Forty Foot Road and is now occupied by antique shops.

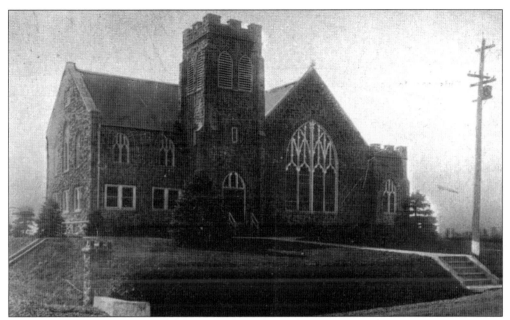

THE REFORMED CHURCH, KULPSVILLE. Montgomery County was home to the first Reformed Church in America, the Faulkner Reformed Church in New Hanover, dating from the 1700s. The term reformed refers to the German Reformed, a branch of the German Lutherans. This building was built in 1912 on Sumneytown Pike west of Kulpsville, though earlier buildings stood here in the 1830s. This view is from 1920 and the building is still standing.

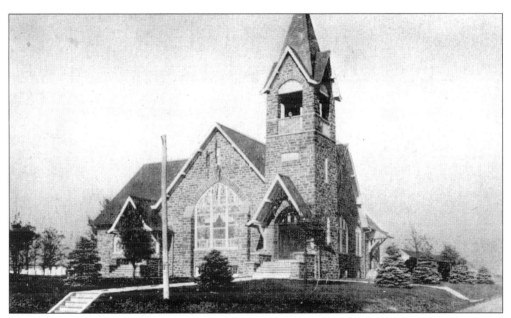

THE LUTHERAN CHURCH, KULPSVILLE. The Lutheran church also had its foundations in Montgomery County with the establishment of the Augustus Lutheran Church in Trappe, dating from the 1700s. This building is located directly across Sumneytown Pike from the Reformed church, which was also built in 1912. Its appearance is similar to this view from 1920.

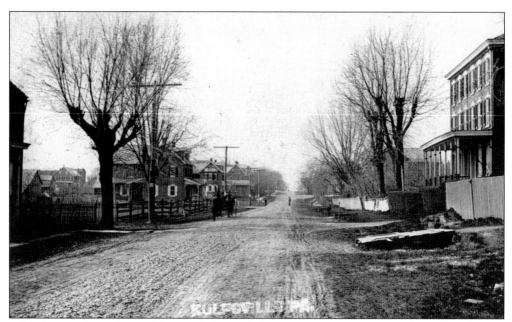

KULPSVILLE. This quiet country view from 1908 of the village of Kulpsville, located in Towamencin Township, looks west on Sumneytown Pike. (Bartholomew postcard.)

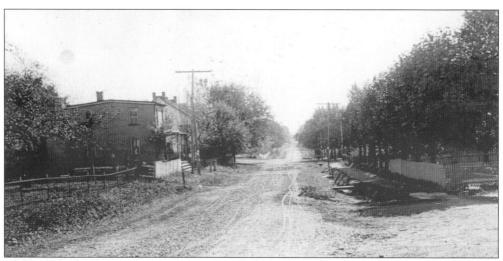

KULPSVILLE. This 1906 view is of Sumneytown Pike looking east toward Forty Foot Road. The two homes on the left are no longer standing, and the emptiness of the roads contrasts sharply with today's traffic. (Bartholomew postcard.)

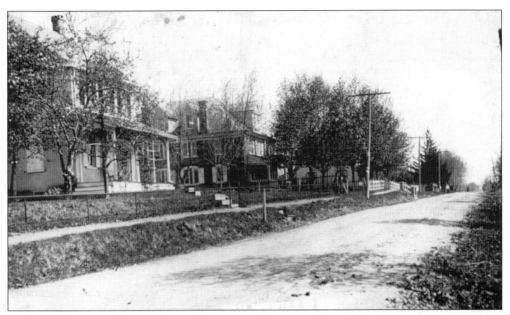

KULPSVILLE. A 1910 view shows homes on the west side of Forty Foot Road north of Sumneytown Pike in the village of Kulpsville. Some of these homes date from the early 1800s. Expanding road projects in Kulpsville have led to some dwellings being boarded up for eventual demolition. (Bartholomew postcard.)

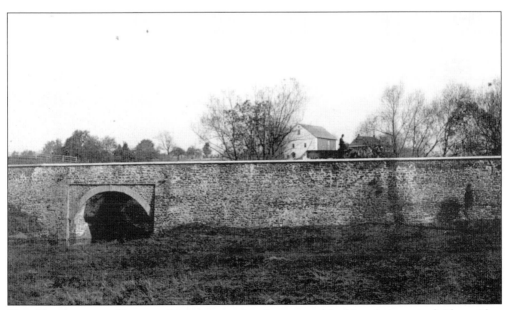

THE TOWAMENCIN BRIDGE, KULPSVILLE. A rather unusual looking, long stone bridge with a single arch is shown spanning Towamencin Creek near Kulpsville in 1911. (Bartholomew postcard.)

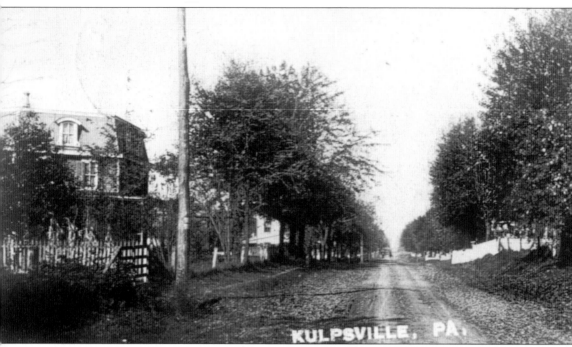

KULPSVILLE. This scene is of Sumneytown Pike looking west toward Forty Foot and Bustard Roads. Note the narrow dirt lane that is the pike today. On the left is the home of John C. Boorse, who was born in 1831. He was a man of many talents and positions; he was a lawyer, surveyor, and justice of the peace. Boorse built this rare six-sided house, which for years was a landmark in Kulpsville, until it was dismantled in the 1990s with the hopes of a later reconstruction on another site. (Bartholomew postcard.)

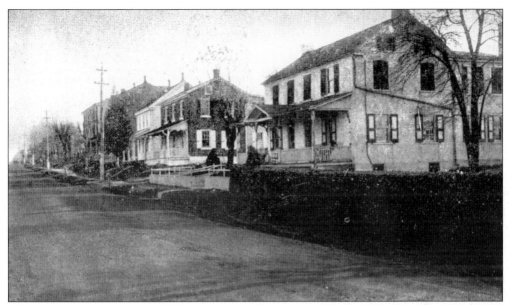

A STREET VIEW, KULPSVILLE. Attractive country homes line the roads in Kulpsville in this 1920 view. Unfortunately, many buildings have been taken down and some are in danger of being demolished due to the never-ending road widening projects that have threatened this venerable and historic village.

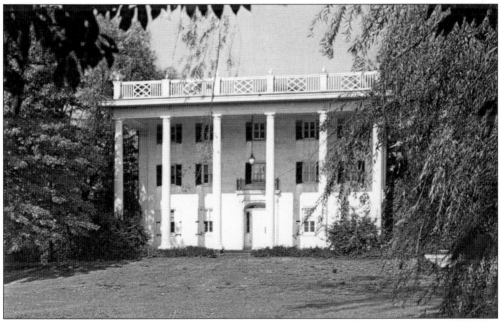

THE CHRISTOPHER DOCK MENNONITE HIGH SCHOOL. Situated on a former farm near Kulpsville, Christopher Dock Mennonite High School is a coeducational senior high school founded in 1953. The school is named after Christopher Dock, a Mennonite schoolmaster who lived in central Montgomery County in the 1700s. Several buildings make up the campus. This building, the old farmhouse, was the administration building at the time this postcard was made in the 1970s.

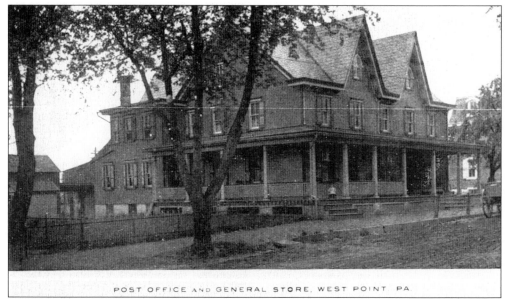

POST OFFICE AND GENERAL STORE, WEST POINT, PA.

THE POST OFFICE AND GENERAL STORE, WEST POINT. The village of West Point in Upper Gwynedd Township owes its existence to the Stony Creek Railroad. This line followed the Stony Creek from Norristown to points west and was in business in 1873. A few industries were built in what was to become West Point, so named because its position was west of the North Penn Railroad line. The general store was built in the late 1870s and is located on West Point Pike. The building still stands and has operated as several businesses through the years.

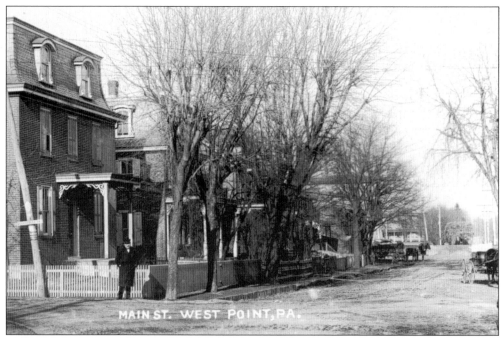

MAIN ST. WEST POINT, PA.

MAIN STREET, WEST POINT. This is a glimpse of the village of West Point along West Point Pike looking north towards the railroad crossing *c.* 1912. West Point was a rather large and prosperous village, with a hotel, general store, numerous businesses, and a railroad station. (Miller postcard.)

126

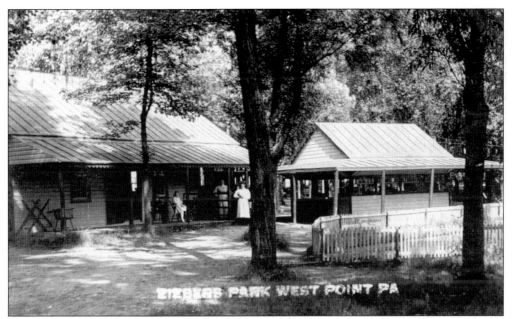

ZIEBER'S PARK, WEST POINT. Zieber's Park, a small picnic and early amusement park, was founded by Civil War veteran Hezekiah Zieber in the late 1860s. This 1908 view shows several picnic pavilions set amongst a rustic setting of mature shade trees. (Bartholomew postcard.)

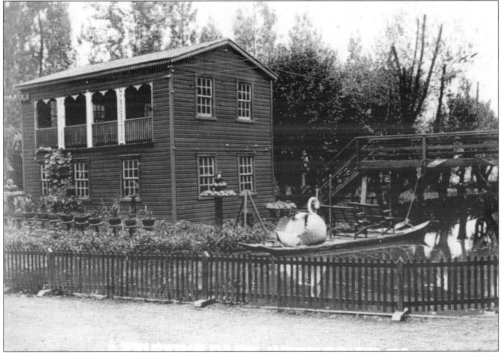

ZIEBER'S PARK, WEST POINT. As the years progressed, many new attractions were added, including a carousel and a lake with various paddle boats. One of the most popular early attractions was the swan boat ride. In this 1905 view, the picturesque lake is accentuated by the swan boat that sits idle, waiting for some pleasure seekers to enjoy. (Bartholomew postcard.)

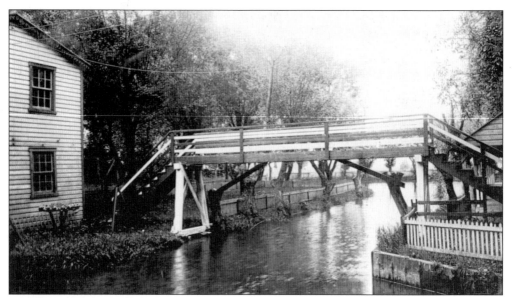

THE SWAN BRIDGE, ZIEBER'S PARK. As the North Penn area's only amusement park, Zieber's Park was well known and a popular subject for early postcards. Trolleys from the Montgomery Traction Company and trains on the Stony Creek Railroad, which ran from Norristown to Lansdale, brought many people to the park. This scene shows the rustic Swan Bridge over the lake on a quiet summer day. (Miller postcard.)

THE RESIDENCE OF L.W. MATTERN, 1915. A testimony to the success and wealth of the village of West Point can be seen in the home of Lesher W. Mattern. Mattern owned and operated a mill and hay press in the village. This elegant Queen Anne, late-Victorian style mansion is rather unusual for a small railroad village like West Point. This building still stands on West Point Pike at Park Road and is now used for commercial purposes. (Miller postcard.)